Ansel Adams

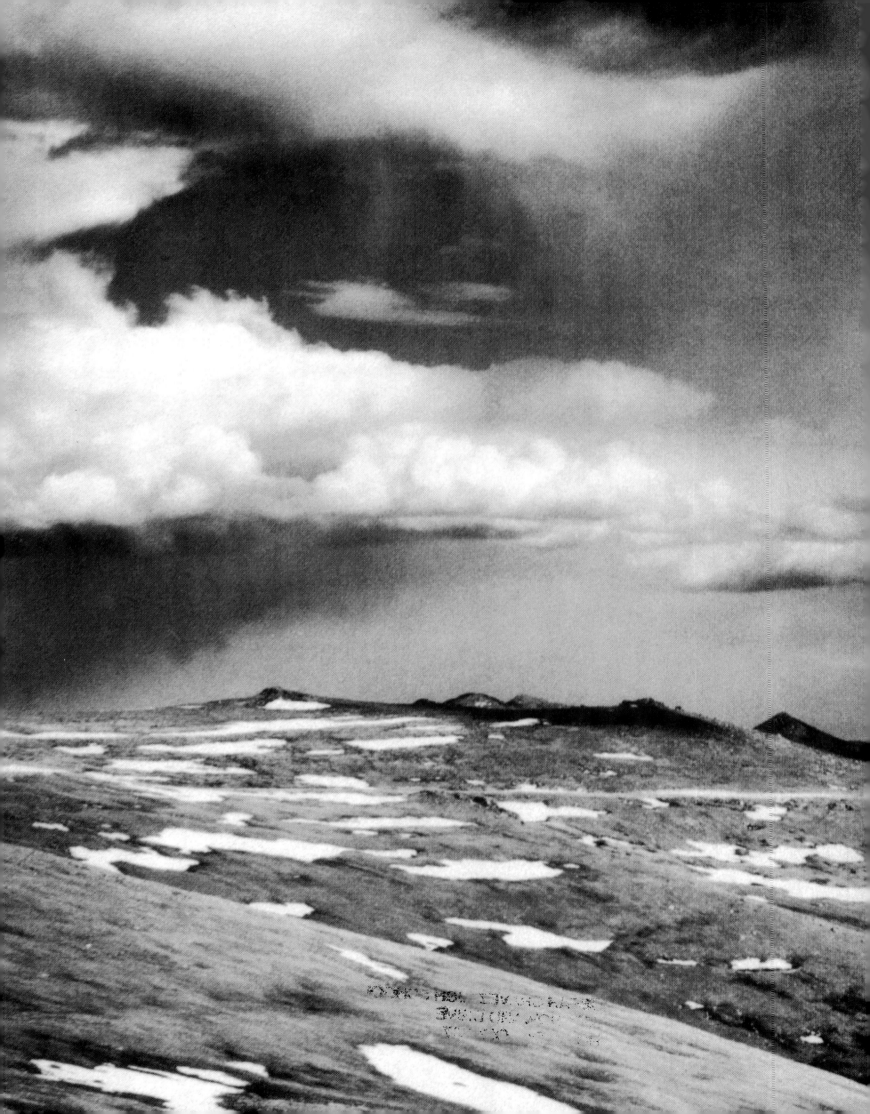

Ansel Adams

Basil Cannon

GRAMERCY

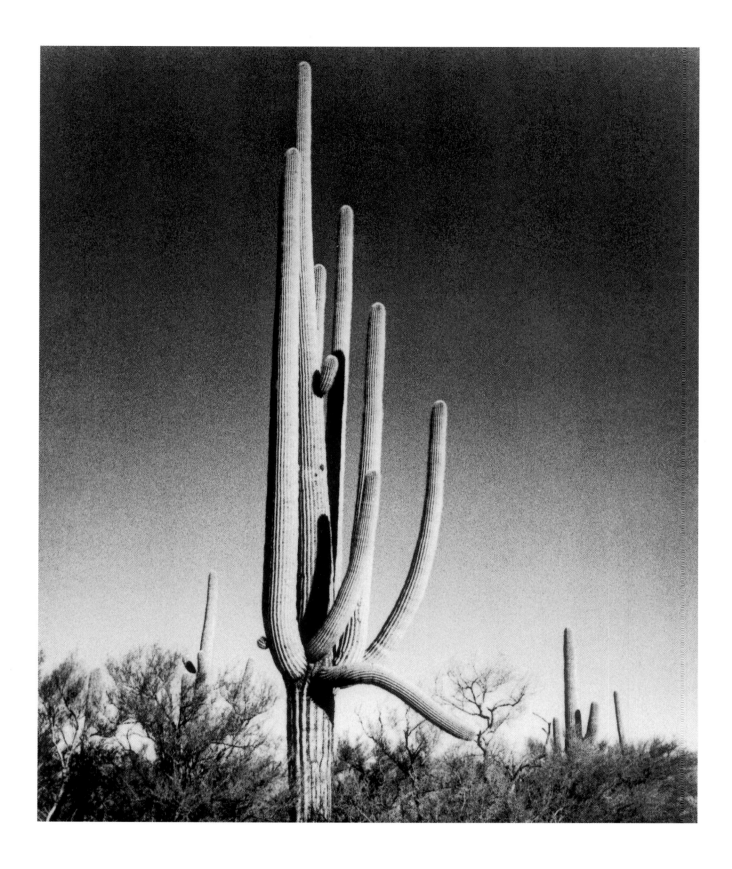

The publisher gratefully acknowledges the National Archives – Records of the National Park Service, Washington D.C., for the use of its photographic prints. This book is independent of, and not authorized by the Ansel Adams Publishing Rights Trust.

This 1999 edition is published by Gramercy Books™, an imprint of

Random House Value Publishing, Inc., 201 East 50th Street, New York, NY 10022

Gramercy Books ™ and design are trademarks of Random House Value Publishing, Inc.

Random House New York • Toronto • London • Sydney • Auckland
http://www.randomhouse.com/

Printed in Singapore.

ISBN 0-517-16119-2

10 9 8 7 6 5 4 3 2 1

List of Plates

PLATE 1
Ansel Adams

Ansel Adams, surveying his beloved Carmel, California, where he eventually built his home and studio. The house became a popular meeting place for aspiring artists of all kinds, all seeking Ansel's advice and approval. He continued to live in Carmel with his wife Virginia until his death in 1984.

Ansel Adams is best known for a series of photographs he took of America's natural heritage, known collectively as the National Park Service Photographs, representative examples of which are reproduced here. This assignment was especially commissioned in 1941 by Harold Ickes of the United States Department of the Interior and the aim was to record for posterity areas that had been designated national parks, as well as the Native American homelands and other monuments and areas of reclamation of the great American wilderness. These would also be used as photo-murals to decorate the walls of the Department of the Interior. Ickes was already familiar with Ansel's work having seen detailed studies of leaves and ferns which featured in an exhibition of 1936. Indeed, he liked them so much that he hung one in his own office. He eventually came to know Ansel when the photographer came to lobby Congress, seeking to have Kings River Canyon, California designated a national park (page 38).

Originally, only painted murals by established artists were thought worthy of the Mural Project, as it came to be known, as photography was not yet considered worthy to be called art, merely a way of recording or documenting reality; but Ickes was convinced that Ansel's work was artistically valid and would make its own inimitable contribution to the scheme.

Unfortunately, due to the ever-increasing threat of war which was looming on the horizon, the project was shelved after a year, but not before Ansel had produced a series of dramatic photographs. The commission came as a godsend to Ansel, being not only a commercial proposition but one which allowed him to engage in his two favourite pursuits, exploring his country's natural legacy and taking photographs which would help popularize his ideas on the importance of conservation as well as enabling him to experiment with photography as an art form.

The collection of works commissioned in 1941 was intermixed with earlier studies of the Kings Canyon area dating back to 1936, and these and the new prints were offered as part of the commission. The photographs are a pictorial testament to the majesty of the American West, captured with technical accuracy and imbued with sheer inventiveness and a deep empathy for the regions which Ansel sought to protect and maintain intact. They range from rivers and canyons, close-ups of plant life, Native American villages and their inhabitants, the mysterious and enigmatic underworld of the Carlsbad Caverns and the geysers and twisted forms of Yellowstone National Park. Together, they offer a visual feast as well as a source of delight and nourishment for the spirit.

Ansel Adams was a true American original and, as one of the most respected and discussed photographers of the 20th century, he has undoubtedly earned his place among America's most popular and celebrated artists. Even after his death, his work continues to impress, inspire and be widely

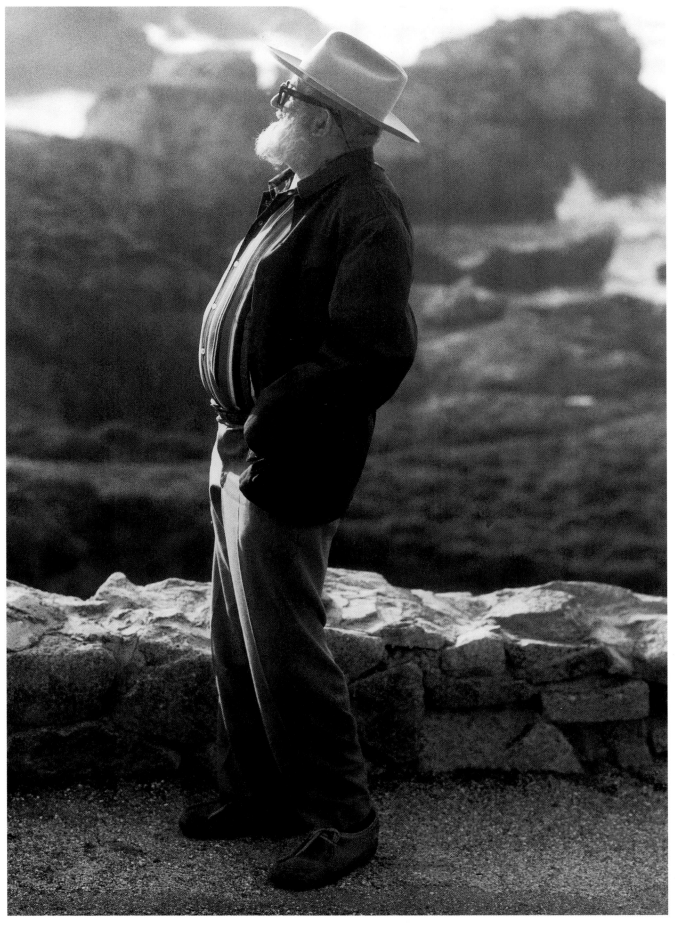

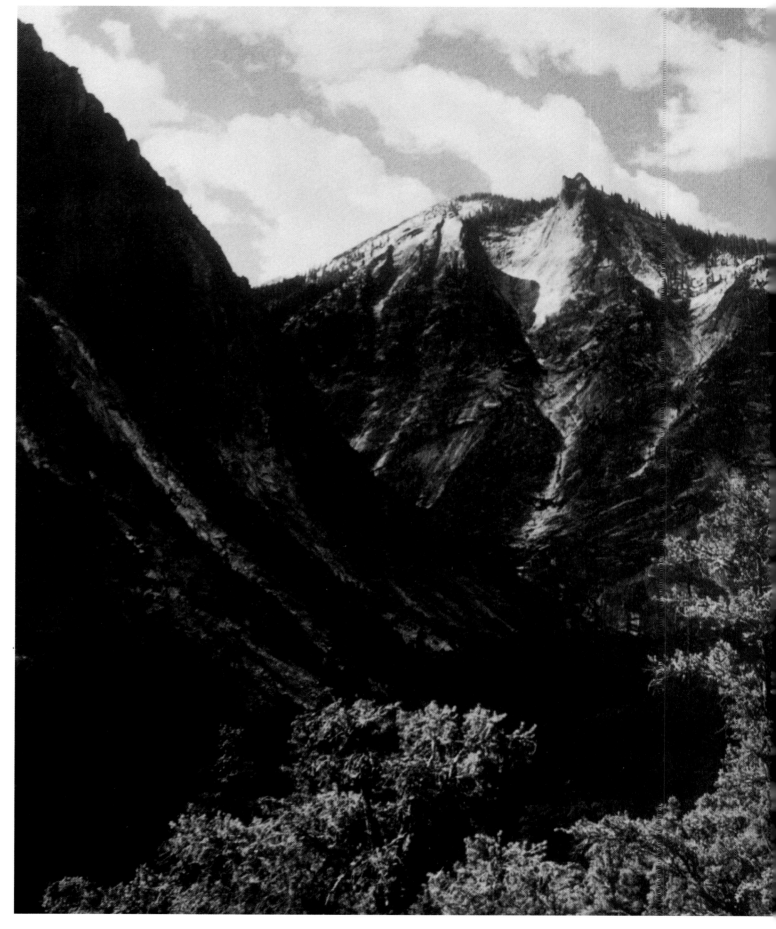

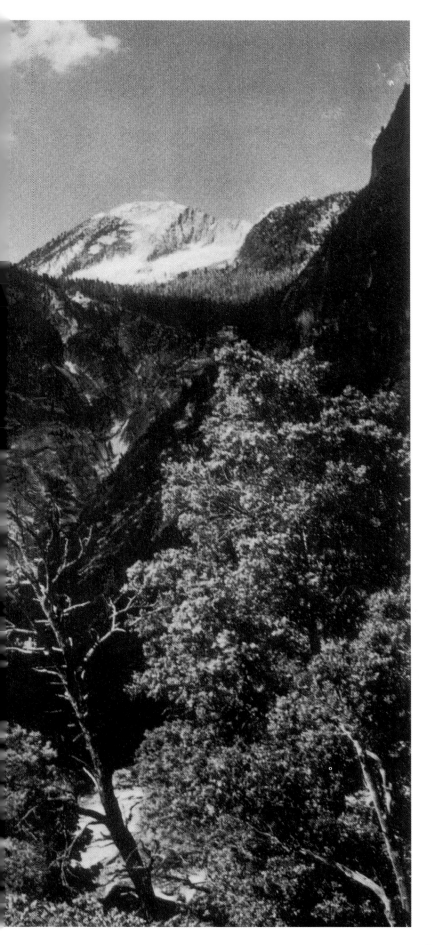

PLATE 2
Paradise Valley
Kings River Canyon National Park, California, 1936

A keen conservationist, Ansel Adams spent a good deal of time and energy campaigning for Kings River Canyon to be declared a national park. This was finally achieved on 4 March 1940. This was the beginning of his relationship with head of the United States Department of the Interior, Harold Ickes, who in 1941 had sufficient confidence in Ansel as a photo-muralist to invite him to contribute to the Mural Project for the Department of the Interior building, the theme to be nature as exemplified and protected in the U.S. National Parks. However, the project was halted by the onset of World War II and never resumed.

The Kings River Canyon photographs were all taken in 1936 and were donated as part of the Mural Project; there are 26 in all.

reproduced. A man variously talented as a pianist, writer, ardent environmentalist, photographer and teacher, Ansel's true vocation, however, was to photograph particular landscapes in his own inimitable way, even though shades of the 19th-century Hudson River School of painters, with their romantic depictions of America as an earthly paradise can be detected in his work. Ansel's intense love of nature and concern for its conservation led him to explore America's magnificent vistas of rivers, mountains and trees, and to discover the native people of its many and varied regions. Throughout his long career and even to present times, his work continues to exert a profound influence, his vision and empathy for the sublime American landscape unmistakably to the fore as the driving force behind his art. The power and energy of his work is astounding and its sheer technical wizardry leaves the observer breathless with admiration. It is perhaps because Adams was above all a conservationalist, and that his work was to a large extent connected with America's national parks, that his popularity is established for all time; his images are austerely beautiful, carefully composed, full of the most potent sense of atmosphere and symmetry. Whatever the subject — the vastness of a landscape or the smallest detail of a plant or human face — the images are powerful and immediate. No one can doubt that Ansel Adams' work is uniquely his own and it is debatable that the power of his images has ever been surpassed.

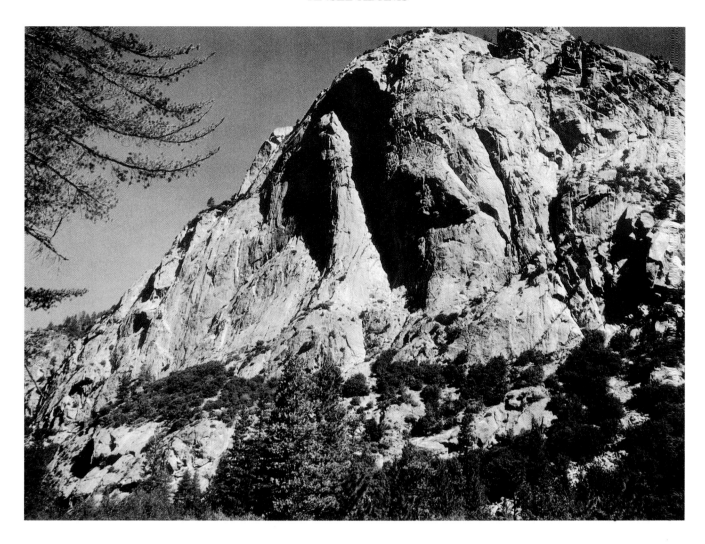

Ansel's love of nature was in all probability a legacy from his father, Charles Hitchcock Adams, a keen proponent of the Emersonian ideal. (Ralph Waldo Emerson was a 19th-century transcendental philosopher who espoused the connection of humanity to a higher Universal spirit.) The Adams family was from New England, having originally emigrated from Northern Ireland in the 1700s. They later settled in San Francisco where a thriving lumber business was founded. Charles had enjoyed all the benefits of a good education and was looking forward to majoring in science at Berkeley's University of California: as a well-to-do young man with a secure future ahead of him, thanks to his father's prosperous business, he had no reason to doubt that his life would continue to be successful and full of incident and that he would in time be able to pursue his greatest love, the study of science. However, this idyll was soon to be rudely shattered when, two years into his science course, the family business began to flounder and his father recalled him, hoping that together they might be able to retrieve what was now a serious situation. The coup de

grâce was delivered, however, when a fire destroyed most of the company's transport ships, resulting in considerable losses. But Charles was an honourable man and spent the rest of his life working to pay off his debts.

Despite his business problems, Charles' personal life was rather more successful. He had met Olive Bray from Carson City, Nevada and married her in 1896. It was in 1902, while Olive was pregnant, that Charles built their family home, situated on the west side of San Francisco amid sand dunes and with stunning views of the Golden Gate Bridge. The house, 129, 24th Avenue, as it was later to become, was in a beautiful setting, the ideal place in which to raise a family. It was far enough from the centre of San Francisco to have a feeling of the country about it and was the perfect playground for the young Ansel who was born during the house's construction in 1902. The great earthquake of 1906 razed much of San Francisco to the ground, but the Adams family home was more fortunate; the house sustained trivial damage, the only casualty being Ansel's nose which he managed to break in a fall caused by the earthquake's

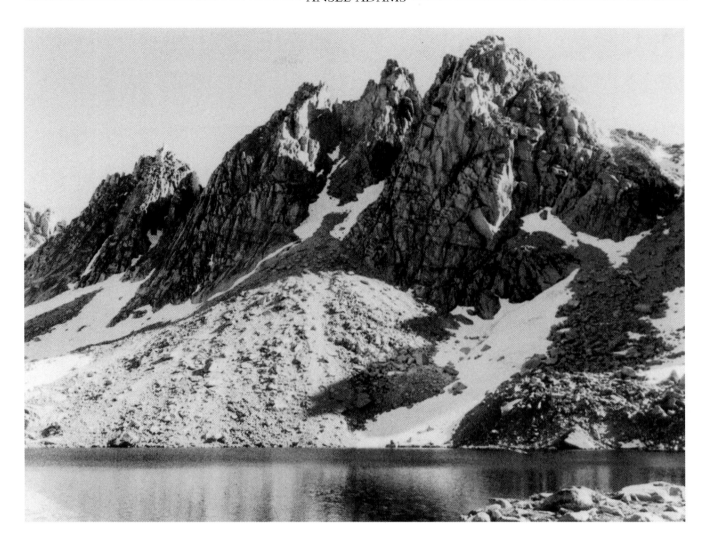

PLATE 3 opposite
North Dome
Kings River Canyon National Park, California

PLATE 4 above
Kearsage Pinnacles
Kings River Canyon National Park, California

aftershock. The trauma of the earthquake had been followed by another tragedy – the death of Charles' beloved father, further aggravated by the ensuing fire and collapse of the lumber business, leaving Charles to pay off the vast debts: the situation was not helped by the arrival of Olive's father and aunt who came to reside with the family on a permanent basis, neither of them having any income to call their own.

These years wrought immense changes in Ansel's young life. Following the earthquake, San Francisco grew even larger and Charles' rural paradise began to be swallowed up by suburbia. Paved streets began to appear and the Adams house became just another in what would come to be known as 24th Street. Ansel was born into a world of enormous change, a time of new and incredible inventions and different ways of thinking: new art movements began to filter through from Europe, and new products and materials began to appear. The major breakthroughs in science and technology were of particular interest to his father Charles.

PLATE 5
Center Peak, Center Basin
Kings River Canyon National Park, California

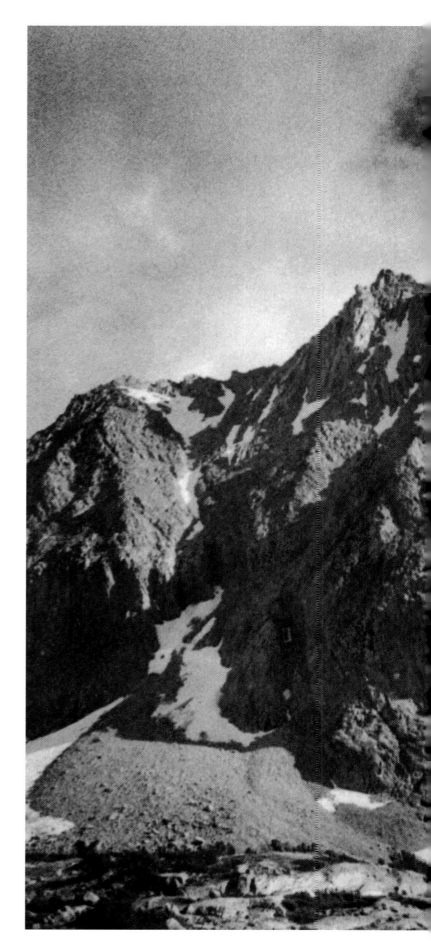

In 1908 Ansel started school. There were problems right from the start because Ansel was an independent and active child who found school discipline hard to accept. This resulted in his transfer to several different schools in an effort to find one suited to his needs. Charles eventually gave up on the search and had Ansel privately tutored which proved to be rather more successful, there being a marked improvement in Ansel's scholastic progress as a result.

In 1915 Charles, who understood his son well, undertook for him a most bizarre form of education. At this time, the Panama-Pacific International Exposition was being held in San Francisco. Charles provided the 13-year-old with a year's pass to the Exposition, thus ensuring an unusual and inspirational education for his son. This was Ansel's classroom for part of each day where he was soon spellbound by the work of the great European painters, Monet, Gauguin, Cézanne and Van Gogh, as well as by the science and machinery exhibits and foreign and American pavilions, some dull, some full of fascination. It was also the first time that he had encountered photography as an art form in three prints exhibited by the Californian photographer Edward Weston, with whom he was much later to collaborate in the f/64 Group project and who became a great friend (page 33 et seq.).

Of course this most unusual education was in addition to his private tutelage and the system was obviously

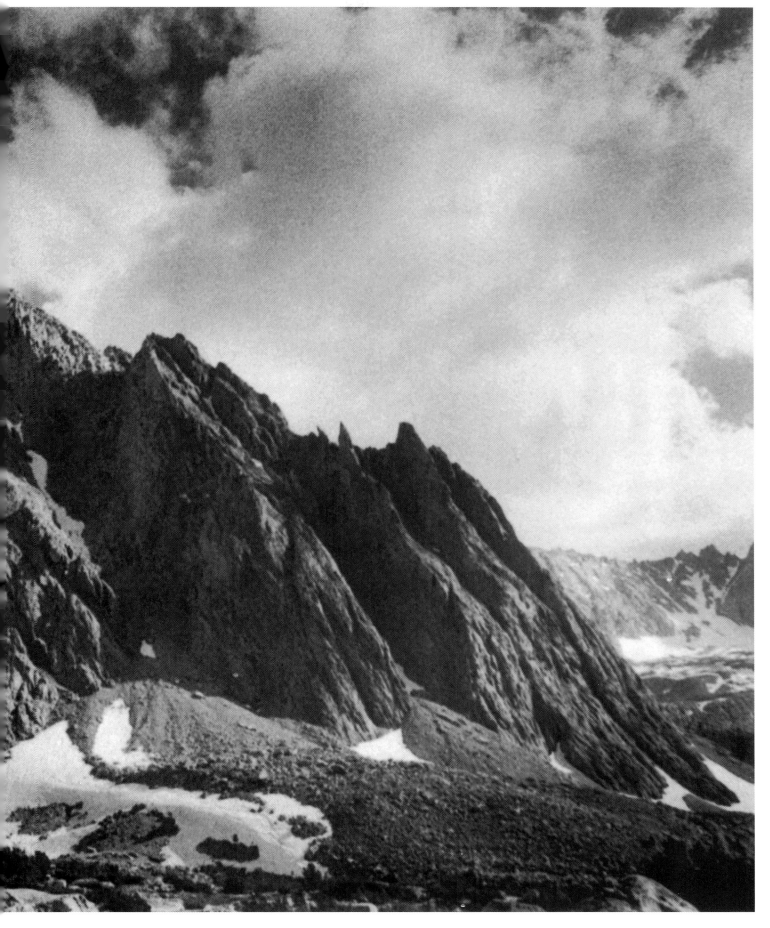

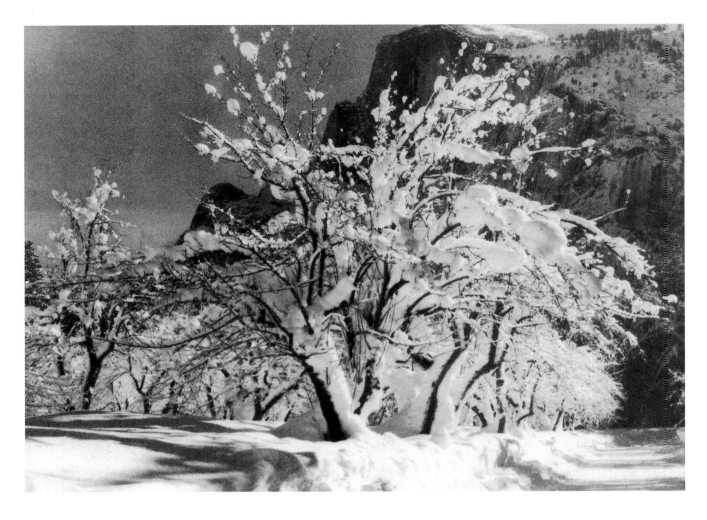

successful, especially when Ansel began to take a keen interest in music, particularly the piano. Ansel taught himself on an old instrument which had stood unused for many years in the parlour and his talent became even more apparent by 1914 when he began to take his music very seriously indeed. His father found a piano teacher for him in the person of Marie Butler, a graduate of the New England Conservatory of Music, who taught Ansel for three years. As he progressed, he became a pupil of Frederick Zech – a formidable figure who was at least 80 at the time, and later, in 1925, of Benjamin Moore, an altogether more tranquil and thoughtful personality. Ansel showed no signs that his interest in music was diminishing, and indeed it was generally considered that he had sufficient talent to become a concert pianist. Although this was not to be the case, it is clear that this early discipline more than influenced Ansel's later meticulous approach to photography. Indeed, he was later to liken the tonal values of a photograph to the individual notes of a musical score.

The year 1916 was to mark the beginning of Ansel's interest in photography. He and his family took their vacation in the Yosemite, where the beauty and majesty of the scenery astounded and delighted him. Yosemite, situated in eastern California, had been declared a national park in 1890 and is 1,189 square miles (3,000km^2) of spectacular mountain scenery, interspersed with waterfalls and tumbling rivers. With his first camera, a Kodak Box Brownie, Ansel's life as a photographer began – an interest which was to endure for the rest of his life. With his first attempts at committing the magic of the Yosemite to film, he demonstrated the beginnings of an immense talent which was to make him a world-class photographer.

As his interest in photography grew Ansel, in the meantime, continued with his piano. His great interest in these fascinating subjects introduced a new maturity and sense of discipline into the life of a previously difficult child, and it gradually became easier to persuade him to attend school again. In 1917 he graduated from the eighth grade of Mrs Kate Wilkins' private school which heralded the end of his academic career.

Although his formal education was now at an end, Ansel continued to pursue his two main interests. As with the piano, he soon managed to teach himself the basic rules of photography and was able to gain further experience in

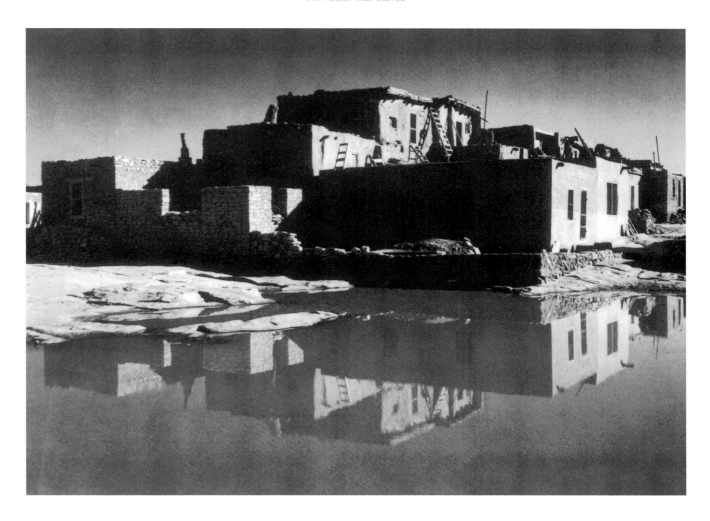

PLATE 6 opposite

Half Dome, Apple Orchard

Yosemite National Park, California, 1933

Yosemite exerted its powerful spell relatively early in Ansel's life when in 1916, aged 14, he and his parents took a family vacation there. It inspired him to experiment with photography using a Kodak Box Brownie. He roamed the area many times, revelling in its savage beauty and returned to the area year after year. This was one of the photographs submitted to the Department of the Interior when Ansel later began his campaign to have Kings River Canyon designated a national park having been a gift from Ansel to the Head of the National Park Service, Horace Albright, in 1933.

PLATE 7 above

Acoma Pueblo

Pueblo National Historic Landmark, New Mexico

1917, working part-time for Fred Dittman as a photo-finisher in San Francisco which, though uninspiring, gave him his first dark-room experience. It was his neighbour, Will Dassonville, an excellent technician and manufacturer of photographic papers, who was Ansel's true inspiration and who brought to his attention the true extent to which photography could be developed into an art form.

It was during the next two decades that Ansel was to grow in artistic stature and to develop an even deeper interest in nature, the environment and music. In the summer of 1919 he took a position as custodian of the Sierra Club's headquarters and continued with this seasonal job for many years. The Sierra Club, an environmental organization founded to educate the public and protect the environment, was instrumental in fostering wilderness treks, mountain climbing and other recreational activities connected with the great outdoors. It was founded by the Scottish naturalist immigrant John Muir, and branches of the club exist to this day all over the United States and Canada. During this period, the piano was still considered to be Ansel's true vocation and he continued to practise at Best's Studio, an organization which sold a variety of books,

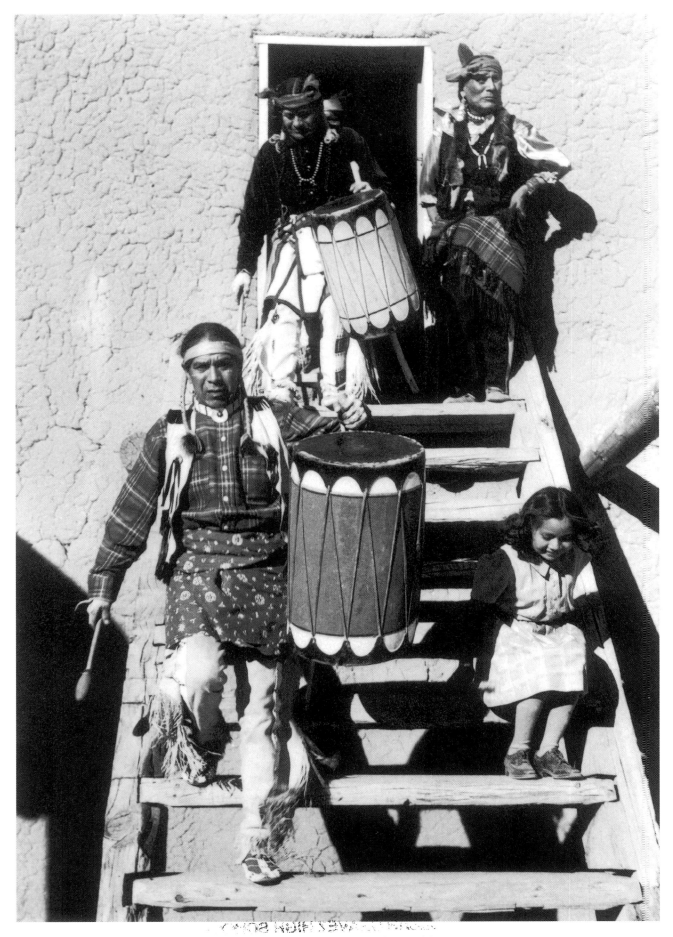

PLATE 8 opposite

Dance, San Idelfonso Pueblo

New Mexico, 1942

PLATE 9 below

Dance, San Idelfonso Pueblo

New Mexico, 1942

gifts (among them rather gimcrack souvenirs), paintings and photographs. It was here that he met and fell in love with his future wife, Virginia Best, a student of classical singing.

As already mentioned, it was the experience of Yosemite that influenced Ansel's understanding of the spirituality of nature, the environment, and the role of photography in capturing it on film began. He made many trips to the higher reaches of the Sierra Nevada on whose western slopes stands the Yosemite Valley. On these excursions, Ansel was often accompanied by an ornithologist called Francis Holman, whom Ansel affectionately named 'Uncle Frank'. Holman was a great source of inspiration and guidance to Ansel, and his deeply-rooted respect for the countryside and animal life stirred Ansel's interest in the natural world. Together, they explored the huge open spaces, visiting areas possibly never seen by another human being, and where they revelled in the vastness and loneliness of the terrain. Ansel's camera was inevitably drawn to the mountains and a love bordering on obsession was born. He began to write articles for the *Sierra Club Bulletin* which he illustrated with his own photographs.

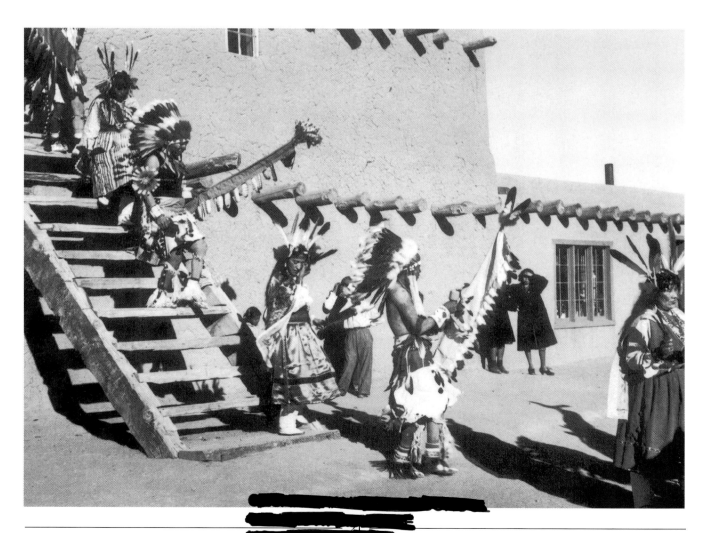

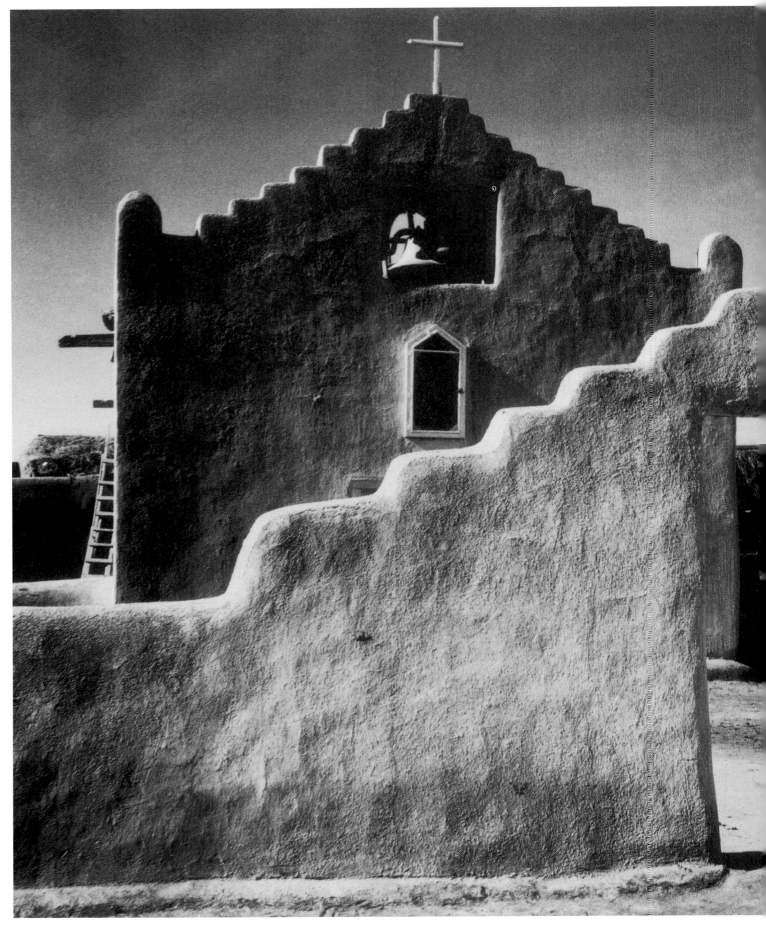

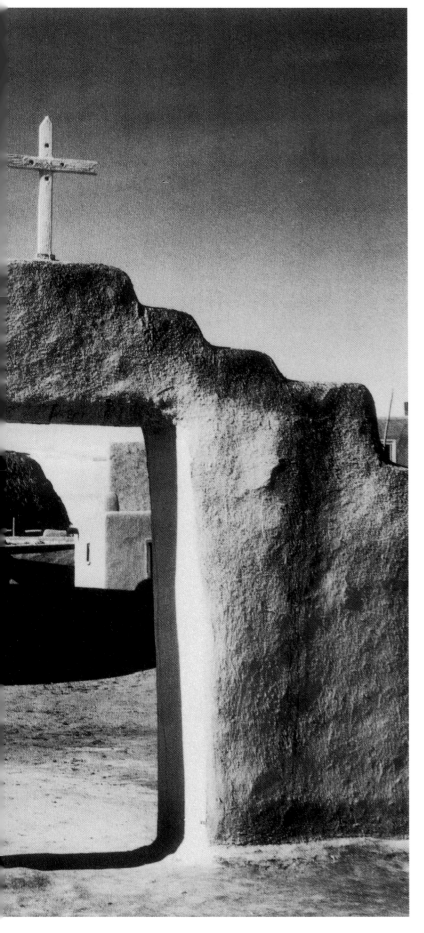

PLATE 10
Church, Taos Pueblo
Historic Landmark, New Mexico, 1942

His love affair with the Yosemite continued as he found himself the leader of an annual expedition sponsored by the Sierra Club. There were over 200 participants, mainly professors and their wives from the nearby universities of Stanford and Berkeley. The treks lasted a month and many a lively camp-fire conversation took place, fuelling Ansel's growing thirst for knowledge and intellectual stimulus.

It was during this period that Ansel began to experiment with photographic techniques and soon developed a way of producing images resembling charcoal drawings. These images were popular among pictorial photographers of the time, and were achieved by using soft-focus negatives and bromide prints. A few of these still remain, of which *Lodgepole Pines* is an example and can be compared against the clarity of his later work. These methods soon failed to satisfy him, and he progressed to more realistic, sharper images, striving to produce an accurate reproduction of the mountains and vistas unfolding before him. It was this clarity of style which was to become his trademark. He realized that taking a photograph in full sunlight gave a dull, flat image, and experimentation at different times of day and under various weather conditions revealed much more interesting and dynamic results: it is the way he utilizes different sources of light which distinguishes his work.

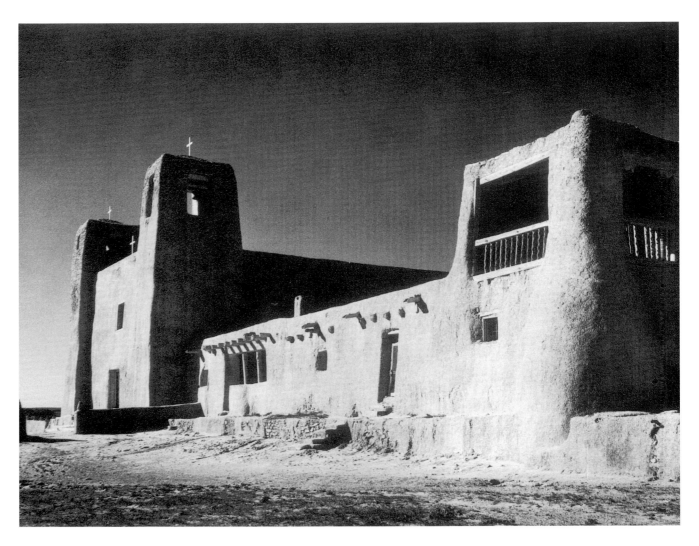

It was Ansel's love of nature and delight in photographing it, particularly areas that remained unspoiled, that was his prime interest and he managed to extend his range to include most of California and, farther to the north, Alaska. It was at this time that he became truly the master of his art. He began to use different lenses for different effects, either to give a feeling of space or to compress an image. He experimented with various types of film to improve these effects, and filters to achieve tonal definition as well as framing to achieve the ultimate result.

In 1923 Ansel began a remarkable friendship with Cedric Wright, the son of his father's attorney and, despite Cedric being ten years his senior, they developed a deep and enduring relationship. Cedric was an accomplished violinist and had evolved his own particular philosophy of life which he transmitted to Ansel, introducing him to the work of Walt Whitman, one of America's major poets and author of *Leaves of Grass* (1855), which was highly praised by Ralph Waldo Emerson and Henry David Thoreau despite failing to achieve public recognition at the time of

its publication. Wright was also a devotee of Edward Carpenter who believed industrial progress to be instrumental in destroying aesthetic values, and added his own ideas on democracy and patriotism to Ansel's Emersonian values to produce a much broader horizon in the younger man. Edward Carpenter, a late 19th-century social reformer was the most inspirational, leading Ansel along new paths of thoughts and ideas and Ansel read his poems constantly, even to the extent of learning passages by heart.

Ansel and Cedric spent a good deal of time in each other's company, both having an overwhelming desire to re-create beauty and dedicate their lives to this ideal. Ansel discovered that he could best portray these feelings through his photography. With a refreshing directness of approach he was able to bring a quality of reality to his subject-matter, especially in his portrayal of the majestic beauty of the Sierra Nevada and outlying areas. It was this immediacy and simplicity of approach which achieved for him an almost instant appeal and it was abundantly clear that he was

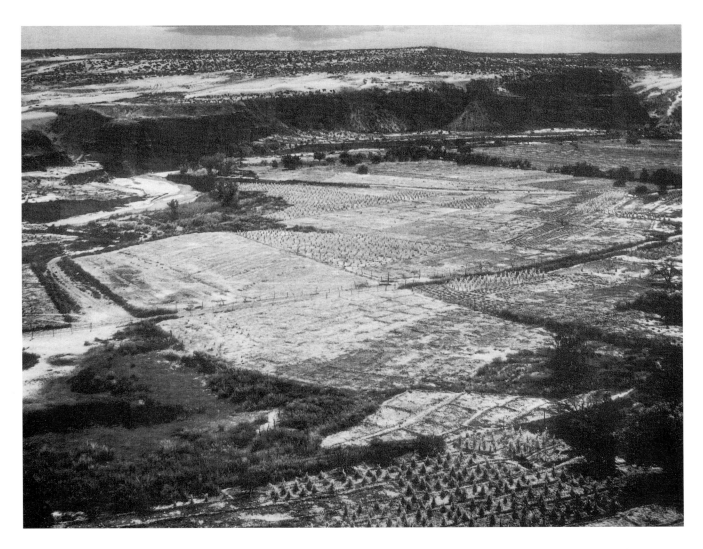

PLATE 11 opposite
Church, Acoma Pueblo
New Mexico, 1942

PLATE 12 above
Corn Field from Indian Farm near Tuba City, Arizona, in the Rain
Arizona, 1941

destined for success in the commercial as well as the artistic world.

Ansel's continuing friendship with Wright led to an important introduction to Albert Bender while at a party in 1926. Bender was a keen supporter of the arts and introduced Ansel to a select group of intellectuals residing in the Bay Area of San Francisco, becoming Ansel's benefactor and promoting his first portfolio, *Parmelian Prints of the High Sierras,* the start of Ansel's professional career as an artistic photographer.

In the first few months of 1927, Ansel began to work on his portfolio and it was at this time that he began to seriously experiment with filters and film to achieve remarkable effects of light and shade. His first breakthrough in these techniques came during a trip to the Half Dome (plate 6) when he was to make a photograph which would radically change his understanding of the medium. He knew that, once climbed, the Half Dome would reveal an incredible vista of the Yosemite Valley. On his arrival, he noticed that the face of the enormous granite rock was

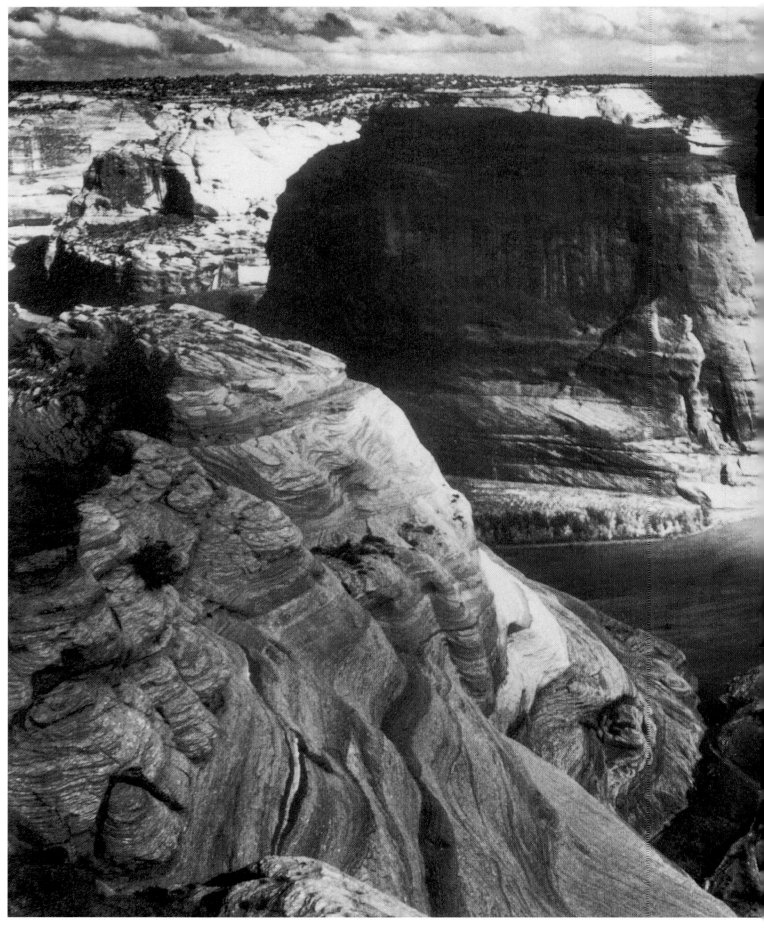

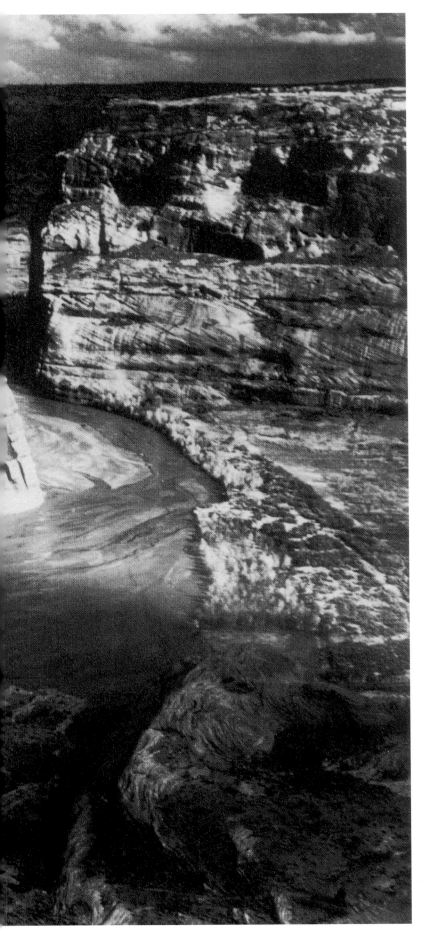

PLATE 13
Canyon de Chelly
Canyon de Chelly National Monument, Arizona

entirely in shade and he was overwhelmed with an urge to photograph the towering structure although he felt that it would be some hours before the monolith was fully revealed in sunlight. He impatiently waited for the light to change and as the sun came round to strike and illuminate the surface, readied himself to photograph it. Having studied his subject, and knowing how films were processed, he was aware that adding a K2 yellow filter to the camera would make the sky a flat mid-grey; he felt that more could be achieved to capture and emphasize the Dome's powerful atmosphere, a brooding cliff framed in a dark sky, so he added a red filter, which reacted with the blue of the sky to achieve a result which, though optically true, made the sky appear more intense, almost black, and imparted a brooding quality to the Dome, emphasizing its vastness. The result is entitled *Monolith, the Face of the Half Dome, Yosemite National Park* and this effect was repeated in many of his later works for the National Park Service where he manages to capture these vast looming rocks, such as the *Court of the Patriarchs* (plate 42), as immensely powerful living organisms emerging from an inky sky darkened by clever technical mastery.

He was so excited with this new-found intellectual approach to photography that he gave it a name – visualization. It was his way of gaining some pre-knowledge of the final image, by manipulating film using filters and different exposures to achieve a certain result, almost like

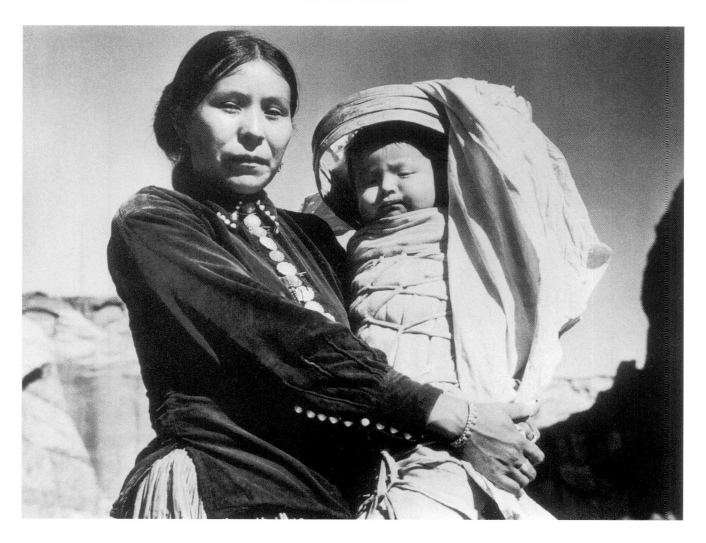

using the camera as a palette, with the photographer as artist. This was a pioneering breakthrough and one which is just as important today but which can only be achieved, however, where a good knowledge of the technical aspects of photography already exist.

In 1928, Albert Bender introduced Ansel to the Roxburghe Club of which he was a founding member. The club was a meeting-place for fine printers of the San Francisco Bay Area and for others with an appreciation of fine printing techniques. It was here that Ansel associated with many of the great printers of the time, including Robert and Edwin Grabhorn of the highly respected Grabhorn Press, who had developed a worldwide reputation for the exquisite quality of their typographic design and printing – also Wilder Bentley of the Archetype Press in Berkeley. Ansel remained affiliated to the club for many years and often held Roxburghe meetings in his own home.

As his works became available in print, he became increasingly aware of the importance of good quality fine printing and continued to espouse this cause. In fact, his first three books were of an extraordinary excellence,

PLATE 14
Navajo Woman and Infant
Canyon de Chelly National Monument, Arizona

PLATE 15
Navajo Girl
Canyon de Chelly National Monument, Arizona

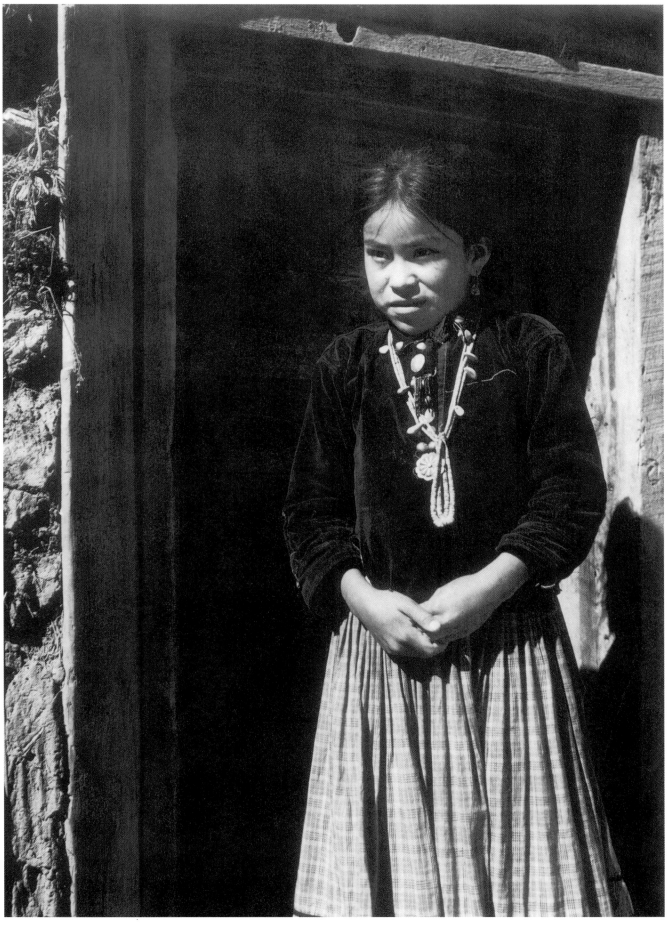

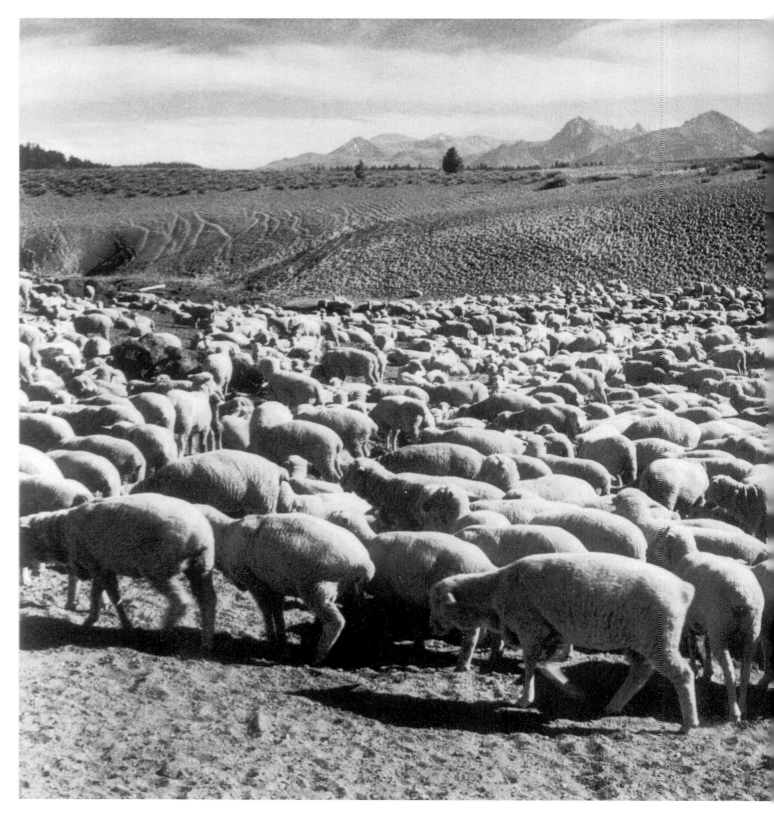

PLATE 16
Flock in Owens Valley
California, 1941

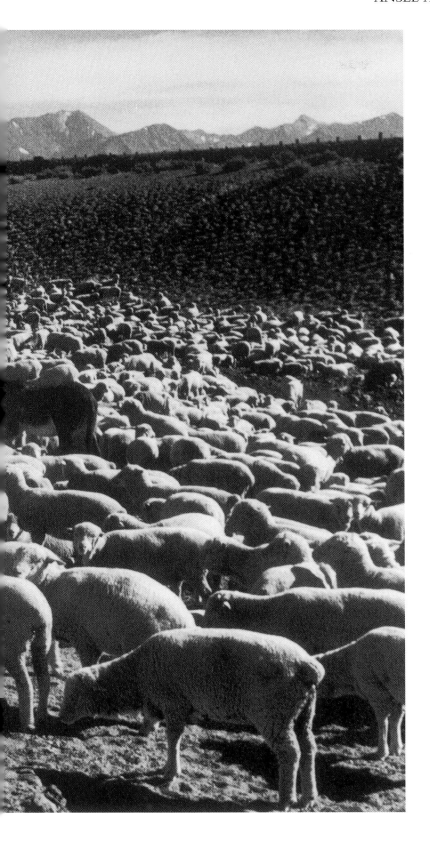

quality being uppermost in his mind given the underlying technical difficulties. However, an excellent result was achieved – far more precise than anything previously seen at the time. These three books demonstrated how far printing was evolving. The first, entitled *Taos Pueblo,* and published in 1930 with text by Mary Austin, was in fact printed by Grabhorn's. Rather than use regular half-tone photomechanical reproductions, Ansel decided to make original photographic prints which were then amalgamated with the text and bound, with only 100 (plus eight artist's copies) of this edition ever being printed. The second book, printed in 1935, was called *Making a Photograph*: this was Ansel's first technical work and this time he allowed his photographs to be printed on letterpress onto a very glossy paper, which achieved an effect very similar to the original. (In fact they were so convincing that a bookstore advertised the book as containing original prints and priced them accordingly; their mistake was swiftly brought to public attention!) These were then hand-tipped onto the pages of the book containing the text. The third book also used the hand-tipping method, and is an excellent example of fine printing at its best. This, entitled *The Sierra Nevada and the John Muir Trail,* was printed by Bentley's Archetype Press and was published in 1936.

Ansel published more than 30 books ranging from limited editions to multi-print runs, most of them of excellent quality. In fact, Ansel's work seems to lend itself particularly well to the printed page.

By 1927, Ansel had begun to grow unsure of his relationship with Virginia Best and their engagement degenerated into an on-off affair. Virginia was a musician and Ansel was realizing that he still had a long way to go before he would amount to anything in this field. However, a visit to Yosemite in the New Year of 1928 caused a sudden change of heart and they were married three days later. When they had been together for two years, they decided to build a new home in the grounds of the Adams family residence in San Francisco where he could be close to his darkroom situated in the basement of the old house. Their new home became a meeting-place for any and everyone interested in the arts and the words 'O Joy Divine of Friends', the title of a poem by Ansel's favourite poet, Edward Carpenter, were inscribed over the fireplace.

Ansel was extremely gregarious, and although it was not unusual for him to work 16 hours a day or more, he still enjoyed parties and the company of friends and like-

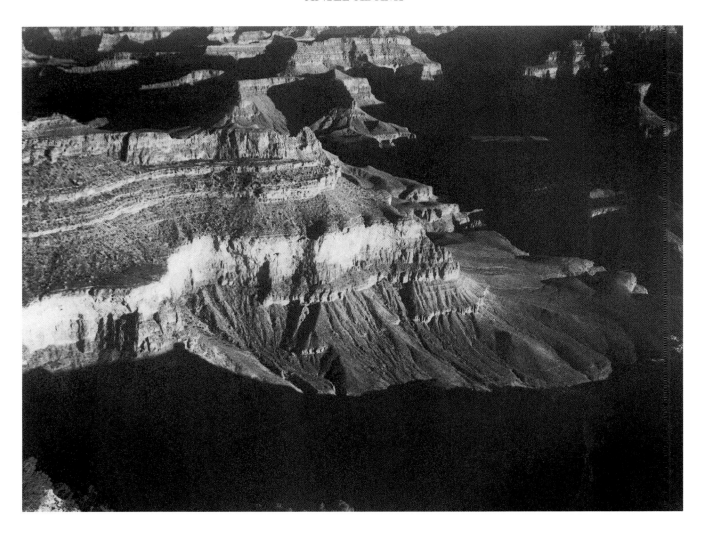

minded acquaintances. In these early years he remained a
much-practised and excellent pianist and his skill gained him
access to levels of society not normally open to a working
photographer. He was frequently asked to play after dinner
and always managed to impress the gathering with his
prowess. It was his talent as a musician which led to an
open invitation to the estate of Mabel Dodge Luhan of
Taos, New Mexico, an influential hostess intent on enticing
promising artists to her fold and to a certain extent helping
them to further their careers. It was during one of his visits
there that he met such well-established figures as Georgia
O'Keeffe, a painter and early member of the artistic
community in Taos and John Marin, a painter and
printmaker, best known for his expressionist watercolours of
Manhattan and the Maine coast.

During another visit to the estate in 1930, Ansel met
photographer Paul Strand. On his arrival he found that all
the artists' accommodation was occupied, but fortunately
Strand and Becky, his wife, offered Ansel a room in the
small adobe guest house that Mabel Luhan had lent them
for the summer. Strand was more than eager to show him a

PLATE 17
Grand Canyon
Grand Canyon National Park, Arizona, 1941

PLATE 18
Grand Canyon
Grand Canyon National Park, Arizona, 1941

selection of his own work which so overwhelmed Ansel that his understanding of photography was crystallized into that one afternoon as he realized its potential as an expressive art. Strand also talked about his life in New York and mentioned his good friend Alfred Stieglitz who had similar views regarding photography. To Ansel, Strand epitomized everything he aspired to be: he too determined that he would strive to become a successful artistic photographer and he vowed to dedicate his life henceforth to this end.

With the path of his future career firmly mapped, Ansel launched himself into a frenzy of photographic projects and in 1931 began writing reviews for a local magazine, *The Fortnightly*. It was at this time that he renewed an acquaintance with photographer Edward Weston, whom he had briefly met some years earlier at Albert Bender's house and whom he regarded as 'a genius in his perception of simple, essential form'. Ansel wrote a favourable review of Weston's work and Weston replied with gratitude, thus establishing an enduring friendship. Ansel's relationship with Weston launched him into a milieu of many like-minded photographers in the San Francisco Bay Area. There he met Imogen Cunningham, John Paul Edwards, Henry Swift, Willard Van Dyke and Sonya Noskowiak who were all, with

Weston, keen to promote the concept of pictorial photography as an art form which they called 'straight' or 'pure' photography. They decided to form an alliance which they named Group f/64.

GROUP f/64

The name originates from the smallest aperture stop on the camera lens, and is identical to the old system number US 256. It is the setting which gives the greatest depth of field, thereby affording the sharpest, purest results.

The group met just a few times and held three exhibitions in all, the first in 1932 being possibly the most important and which was held at the M. H. de Young Memorial Museum in San Francisco. The members of the group were not interested in political issues as many art groups were; they preferred to focus on their own personal ideas and used the exhibition to promote their own 'visual' manifesto. They saw their style of photography as a new American art form, conforming to strict guidelines of *pure* photography: they were not interested in soft-focus romantic images – their aim was sharpness, purity and clarity. To achieve these results they used very glossy paper in an effort to reproduce a full tonal range, from the heaviest blacks to

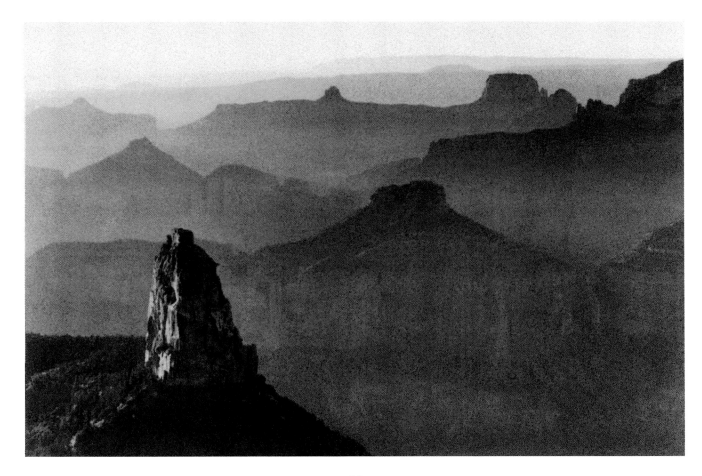

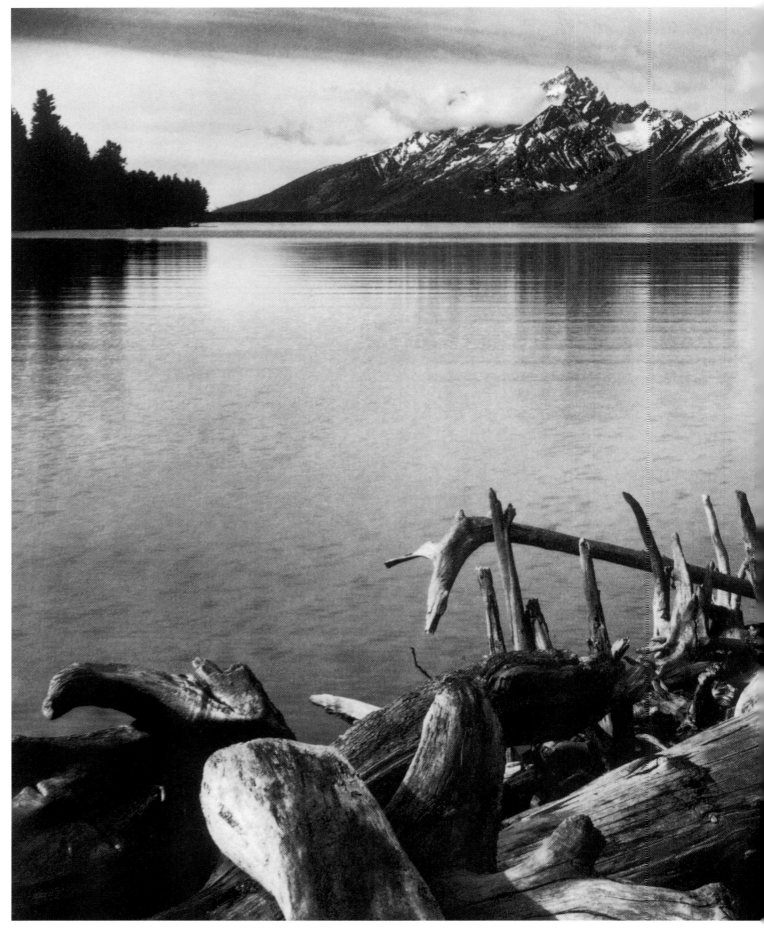

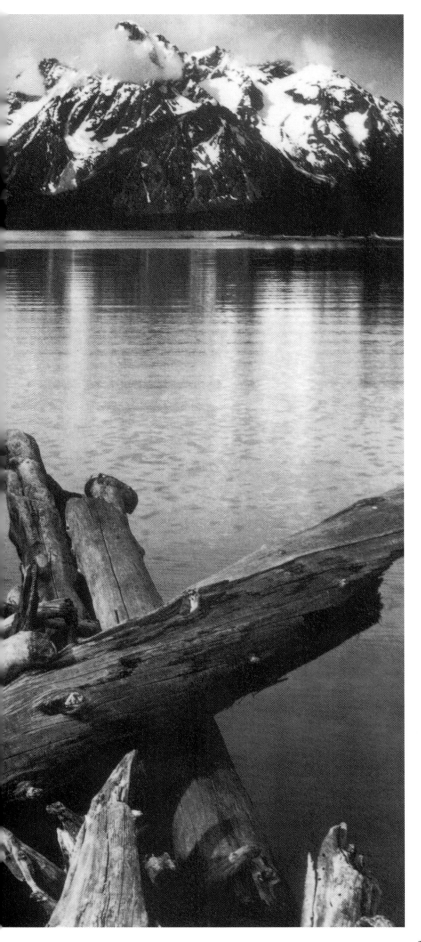

PLATE 19
Untitled
Grand Canyon National Park, Arizona

the purest of whites. They favoured a large-format view-camera and printed by contact sheet, avoiding enlargement which would render the image grainy, and result in lack of clarity and purity. The group used everyday objects as well as images from nature as their subject-matter (incidentally, also Ansel's preference) – all in natural light – both near and far objects being photographed with pin-sharp clarity. Although there were only three exhibitions of their work, and they were not a particularly close group in any case, f/64 was to become the most significant influence on modern photography.

As well as growing creatively and gaining a greater understanding of his medium, Ansel also began to undertake commercial work. Both Paul Strand and Edward Weston supplemented their incomes in this way and, while Ansel gave these assignments his full attention, he made clear delineations between the creative element, which he referred to as 'within', and the commercial which to him was 'without'. Ansel's gift of technical expertise meant that he was able to make an easy transition to colour photography and he used it for many commissions, including projects for *Fortune* and *Life* magazines and the Eastman Kodak Company. These commissions produced a lucrative source of income which continued well into the 1970s. However, he tended to avoid colour in his creative photography; he abhorred the lack of control that resulted and felt that the depth of emotion he was

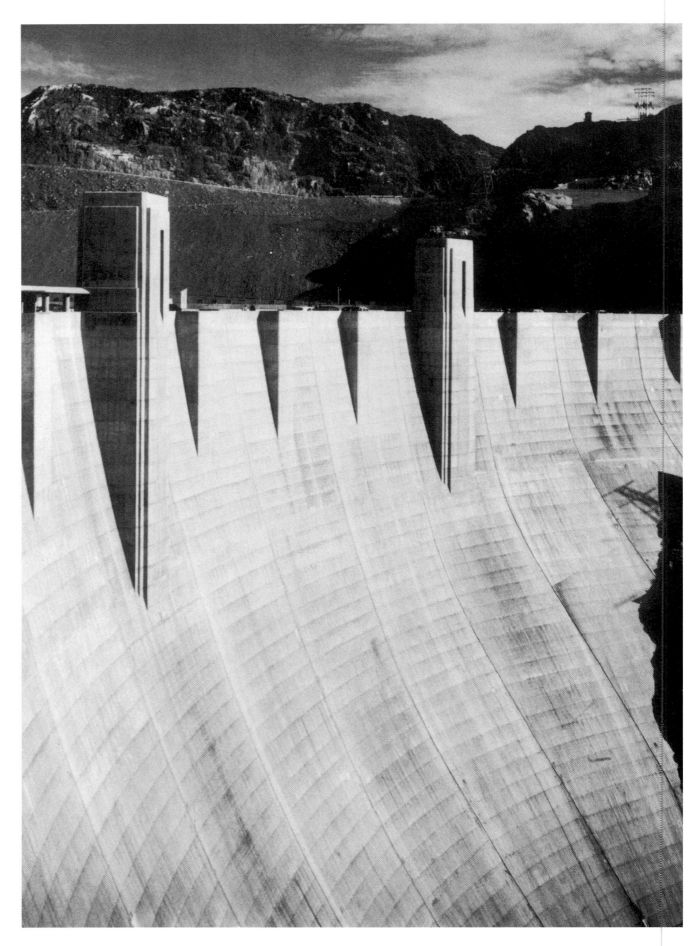

PLATE 20 opposite
Boulder Dam
Colorado, 1941

PLATE 21 below
In Saguaro National Monument
Arizona

attempting to portray in his work could only be successfully achieved in black-and-white.

Over the years, Ansel had met many influential people in the arts as well as other like-minded photographers. However, the person most important to Ansel's career was Alfred Stieglitz who played a vastly important role in the recognition of photography as an art form. In the early 1900s he had inaugurated his Little Galleries of the Photo Secession at 291 Fifth Avenue, New York, where he not only displayed the work of modernist painters but also fine-art photographic prints and had even produced his own series of photographs of sun and clouds entitled *Equivalents*, taken in the 1920s with a Graflex camera. The photographs, like Ansel's, range from intense blacks to purest whites, with luminous tonal greys between.

In 1933, Ansel decided to visit Stieglitz at his New York gallery, An American Place, which acted as a magnet for the musicians and artists of 1930s New York. The meetings were fruitful and their growing mutual respect for one another resulted in Stieglitz providing Ansel with a one-man exhibition in his gallery in 1936, the first photographic exhibition he had given since Paul Strand's in 1917. This inspired Ansel to create his own creative studio in Geary Street, in San Francisco, and he called it the Ansel Adams Gallery.

Wild and uninhabited areas had always been important to Ansel, places which provided him with a sense of

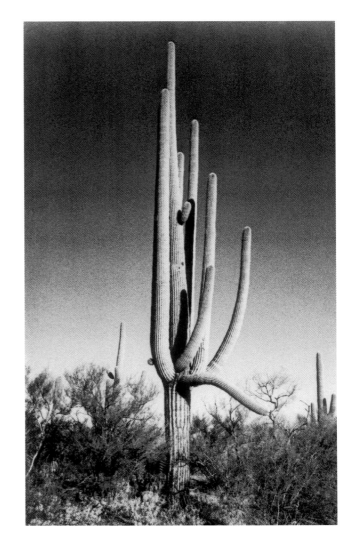

spiritual renewal and which presented him with the opportunity of escaping from the rigours of an urban existence. Ansel continued his association with the Sierra Club and was elected to the Board of Directors in 1934. During this time it was becoming increasingly evident that the natural beauty of the wilderness was in danger of being overrun by tourists, with roads and railroads proliferating to transport them back and forth. Once-beautiful places were being marred by ice-skating rinks, bowling alleys and recreational areas; Ansel's world was gradually and irrevocably being eroded.

With the advantage of his position in the Sierra Club, Ansel embarked on a tireless campaign to protect important sites of natural beauty and in 1935 began to lobby Congress to make the Kings Canyon region of the Sierra Nevada a national park. The 1930s had brought a new awareness of the importance of conservation and Franklin Delano Roosevelt became a keen supporter of the cause for conservation and appointed Harold Ickes as director of the Department of the Interior, to be in charge of the National Park Service.

Ansel saw that some further impetus was needed to emphasize the importance of his cause and decided to use his own work, carefully selecting a series of his most beautiful photographs, which included *Half Dome, Apple Orchard* (plate 6). In 1937, the bill for Kings Canyon was re-introduced to Congress and was again lobbied in 1938 by Secretary Ickes. Ansel made use of another tool, his recently published *Sierra Nevada and the John Muir Trail,* which he sent to the director of the National Park Service. The book was taken to Ickes who presented it to Roosevelt, the beauty of Ansel's photography encouraging the president to sign the bill, and in 1940 Kings River Canyon became a National Park.

This was one of many issues of conservation which confronted Ansel in his lifetime. He was even engaged in a scuffle with his largest commercial client, the Curry Company, which was a major owner of the Yosemite parks concessions. He did not approve of the way that his photographs were being used to attract tourism alone; he had intended them to make the public aware of the powerful beauty of the wilderness and the need for its

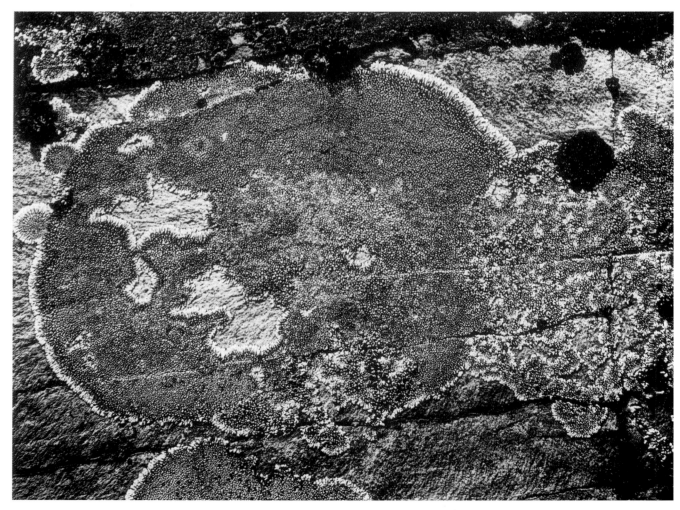

PLATE 22 opposite

Lichen, Glacier National Park

Montana

PLATE 23 below

From Logan Pass, Glacier National Park

Montana

conservation. Ansel fought all his life for this concept and won many battles, helping to preserve some of the most beautiful landscapes in America for future generations.

In 1936 Virginia's father died and she inherited Best's Studio. The following spring Ansel, Virginia and their two children, Michael born in 1933 and Anne, in 1935, moved to Yosemite. Ansel now had unlimited access to the park and was able to be close to his client, the Curry Company. He still regularly travelled the five-hour drive to San Francisco to take care of his studio and other business concerns which continued to disrupt family life until Ansel and Virginia moved to Carmel in 1962.

During the late 1930s, Ansel made two important new friendships – with Nancy and Beaumont Newhall – a relationship which was to span 30 years. Ansel, along with Beaumont and David McAlpin, played an important role in establishing a department of photography in the Museum of Modern Art in New York City and Nancy Newhall worked closely with Ansel and wrote many of the texts for his books as well as becoming his first official biographer. In fact, it was on a journey along the coast from San Francisco

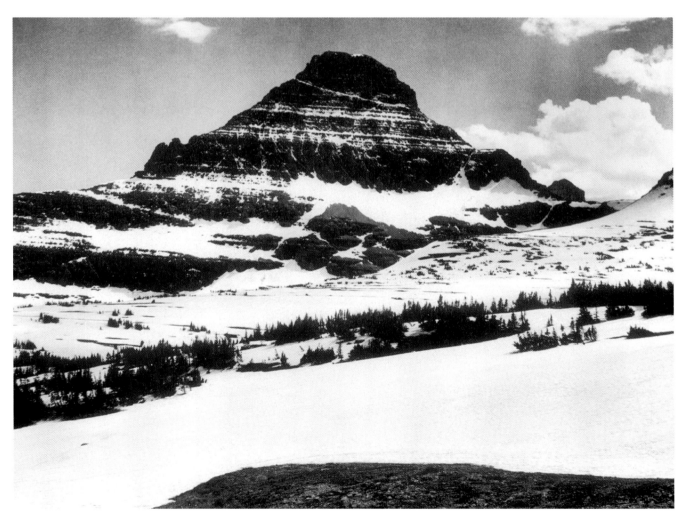

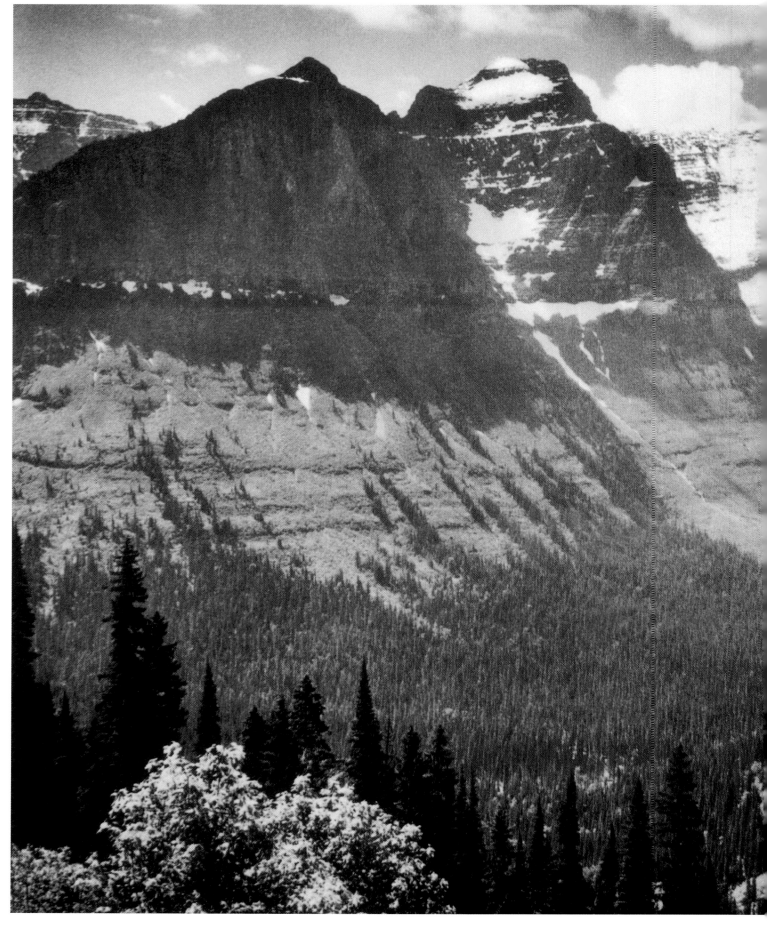

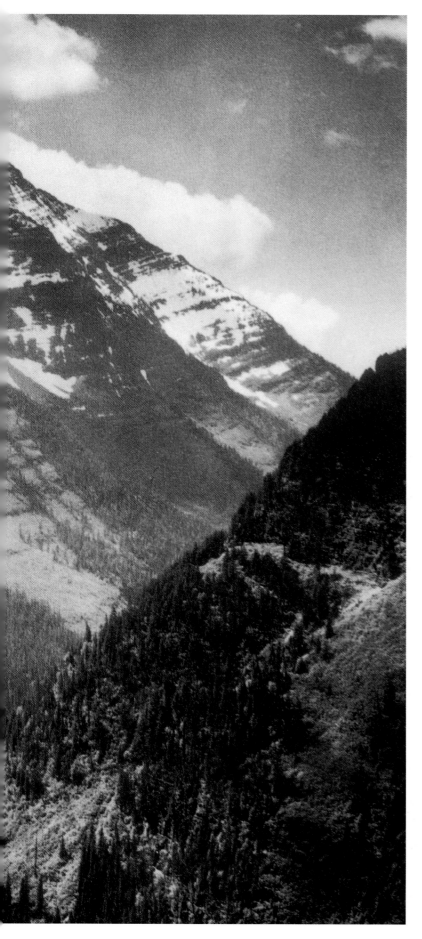

PLATE 24
In Glacier National Park
Montana

to Carmel, the purpose of which was to introduce the Newhalls to his friend and associate Edward Weston, that Ansel took a remarkable sequence of photographs.

This is called the *Surf Sequence, San Mateo County Coast, California,* and consists of five prints designed to be viewed together. Having aimed his camera directly down the cliff face, the scene gives a vivid impression of waves relentlessly advancing and retreating from the shoreline. Using photography to suggest a feeling of movement was certainly an innovation and had never before been achieved: these images work so well together that one can almost hear the surf as it rolls over the beach below.

The 1940s saw Ansel at his most prolific, producing some of his best work. As well as the Mural Project for Secretary Ickes, he was at his creative peak and actively involved in teaching projects and writing books on the photographic techniques he had developed, including an explanation of his ten-step Zone System to creating pictures full of clarity and emotion. This he introduced in 1941, being a simple way of explaining sensitometry, a device for measuring photographic equipment's sensitivity to light. His method was to divide the tonal range into ten steps, starting with zone 0 for total black to zone 9 for pure white. This innovative idea allowed the photographer to gauge the contrast and tonal quality by developing the film to these specifications to achieve optimum results in the final print. Even nowadays, with modern film which reacts differently,

the Zone System is still used by serious photographers who require perfect results.

Ansel also held and organized many exhibitions. Of course, the 1940s also saw America's involvement in the Second World War but at this time, Ansel himself was not actively engaged though he was desperate to make his own contribution to the war effort. This he achieved in minor ways by teaching photography to officers, but more importantly by embarking on a series of prints spanning a four-year period from 1941–1945, and designed to inspire the American nation into believing that their country was truly worth fighting for. The results were sweeping vistas with creative effects of deepest blacks to whites which achieved an almost surreal effect of astounding quality. The power of these images conveys an enormous depth of emotion; Ansel in his creativity was aiming to visually express the true America of democracy and truth, translated through the majesty and vastness of the American landscape.

The first of these images taken in 1941 and called *Moonrise,* was photographed in October at Hernandez, New Mexico, just before sunset. The blackness of the sky takes

prominence with the last of the light falling on the crosses in the cemetery and on the roof of the church; it is spiritual in its concept, symbolizing not only man's puniness in the vast expanse of the landscape but also his relationship within it.

The Tetons – Snake River, Grand Teton National Park, Wyoming, one of a series (plate 39), captures the overwhelming magnificence of the American landscape – this time with land dominating the sky. Once again, the intense contrasts of light and dark impart a penetrating luminosity to the scene.

Clearing Winter Storm, Yosemite National Park, is truly a masterpiece, having an entirely different feel to the previous two; it has incredible depth and detail – one can almost feel the spikiness of the pines and the tingling spray of the waterfall. The clearing storm is almost tangible as it snakes through the mountains, achieving an acute sense of three-dimensional reality. The photograph was taken overlooking the Yosemite, the spot being a favourite of both photographer and tourist alike, offering a spectacular and awe-inspiring view over the valley.

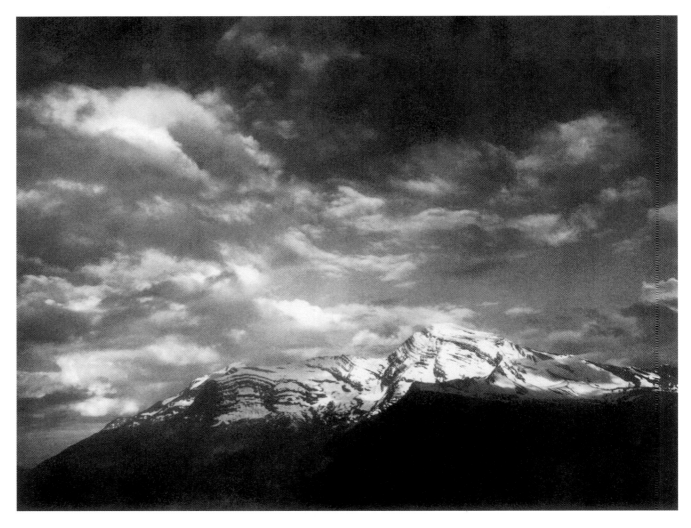

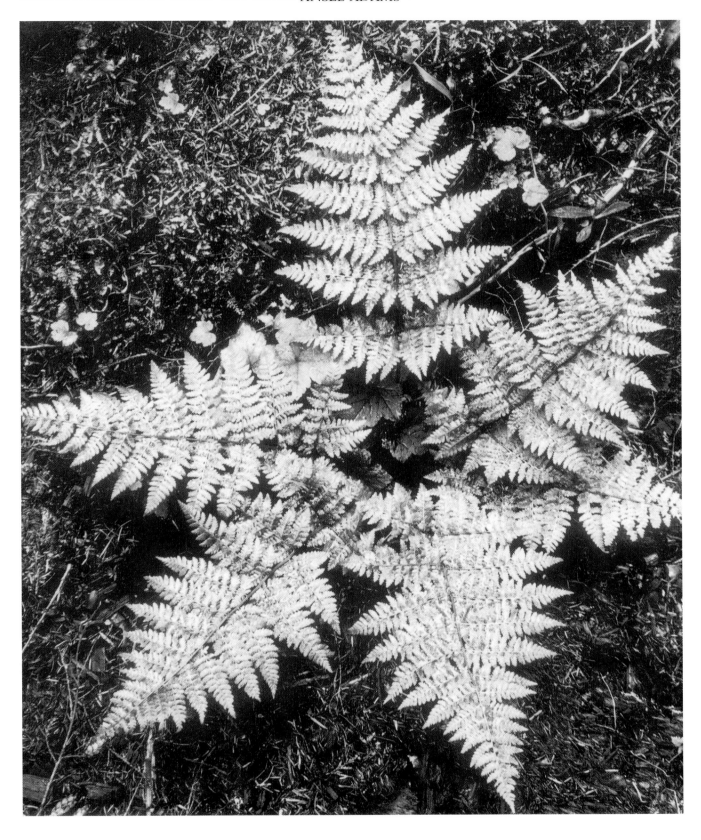

PLATE 25 opposite
Heaven's Peak
Glacier National Park, Montana

PLATE 26 above
In Glacier National Park
Montana

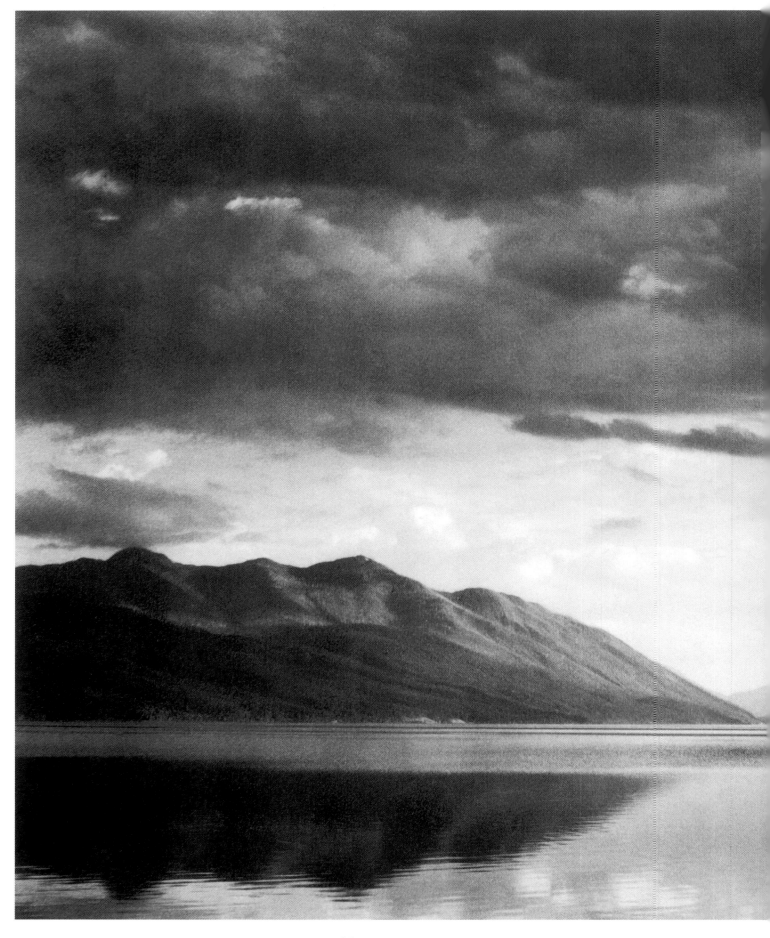

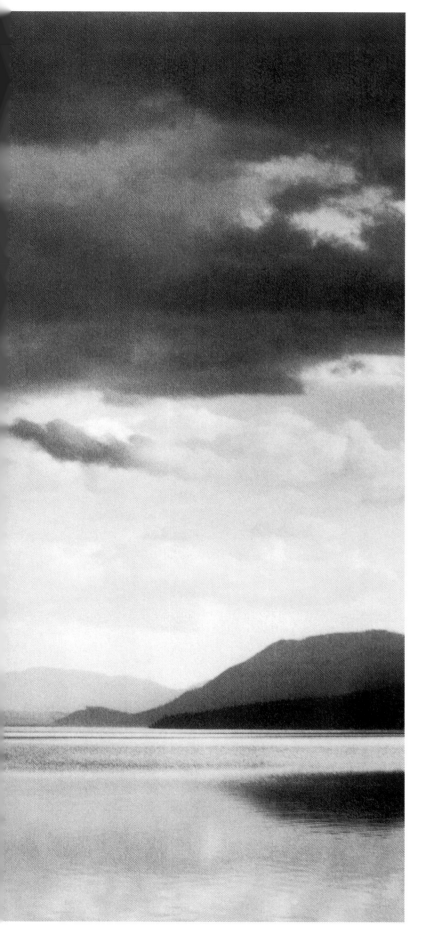

PLATE 27
Evening, MacDonald Lake, Glacier National Park
Montana

Winter Sunrise, The Sierra Nevada, From Lone Pine, California presents a powerful dramatic image, but once again, is packed with incredible detail; even through the darkness of the foreground, trees, plant-life and a lone animal can be viewed with perfect clarity. The more the picture is studied, the more its hidden depths are revealed. Ansel uses a very different approach to the previous images with his final picture of the series, *Mount Williamson, Sierra Nevada, from Manzanar, California*. This time, his intention is not so much to attempt to capture the vastness of the landscape, but to use boulders to create almost abstract images. Once again, the minutest details are evident – one can almost count the rocks as they recede into the distance of the mountains.

Ansel was deeply worried by the plight of the Japanese-American people and their treatment during the war so, when asked if he could produce a pictorial document on the Japanese prisoners-of-war interned in the detention camp at Manzanar in the Sierra Nevada, he approached the commission with his usual sense of commitment. The result is a series of photographs portraying a proud race who have suddenly found themselves in difficult circumstances. The pictures were published in a book called *Born Free and Equal* (1944), being created to Ansel's own code of perfection and full of powerful imagery. He also wrote the text which was just as heartfelt and was probably his most important contribution to writing.

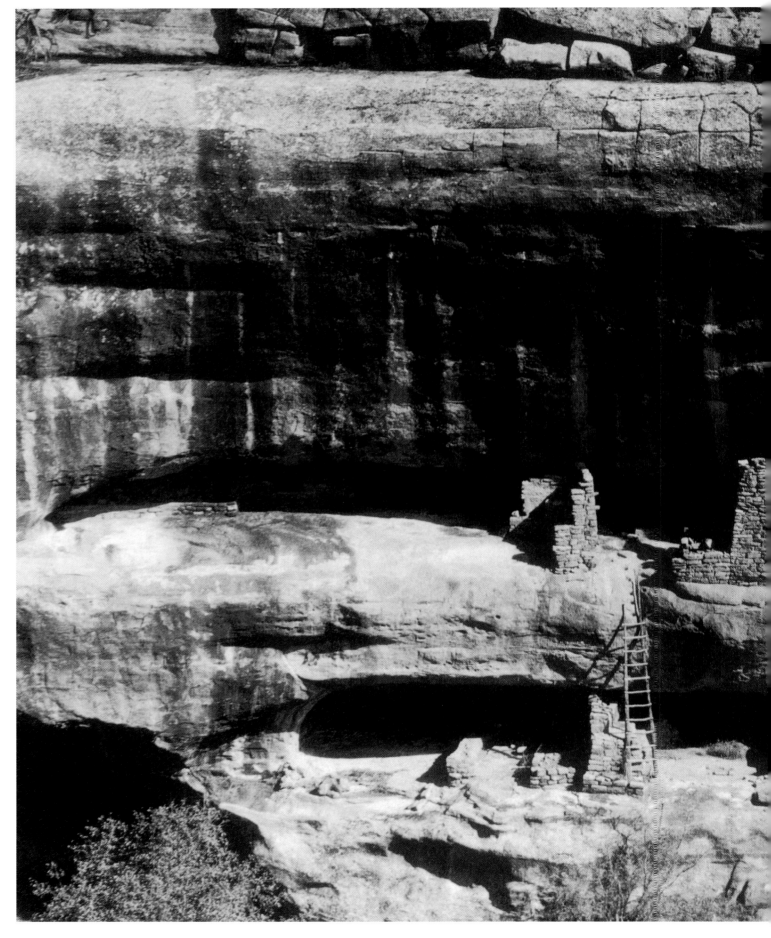

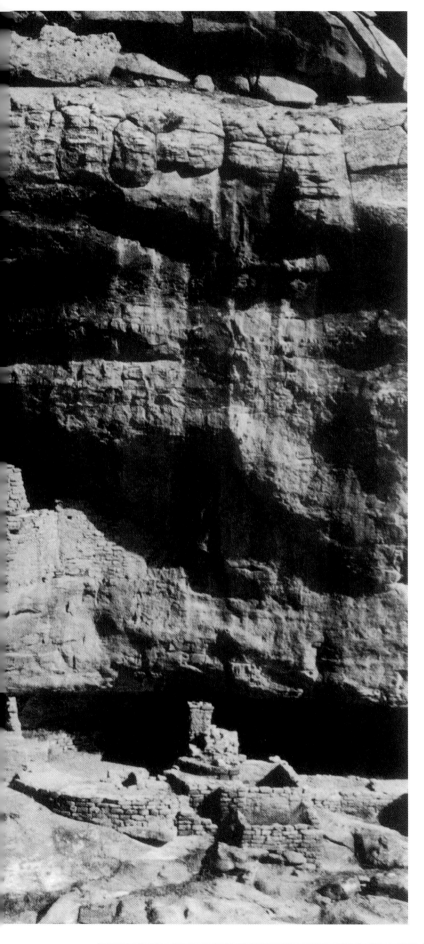

PLATE 28
Mesa Verde National Park
Colorado, 1941

The 1940s saw the apogee of Ansel's genius. He was a prolific author of technical books and the publication of two on his basic technical theories, *Camera* and *Lens* and *The Negative,* were produced. He also published *Portfolio 1*, the first of six portfolios of images he was to create over the next 30 years. He was also a regular lecturer in creative photography at this time, as well as a continuing and ardent champion of the environment.

In 1946, Ansel received the first of two fellowships from the Guggenheim Foundation and another followed in 1948, allowing him sufficient financial security to enable him to spend even more time on his creative work and to concentrate on the national parks throughout America and further afield in Alaska and Hawaii, places he was to visit for the first time. However, Ansel's images were not solely intended to emphasize an environmental point of view, they were predominantly a celebration of the beauty of America although, on many occasions, his photographs were used to support environmental issues – something he welcomed and encouraged. It was during this time that he produced some interesting images of a somewhat different nature to his usual dramatic landscapes relying on the common theme of the curved line, simplistic in form with a clear precise beauty of line.

Towards the end of the 1940s, Ansel made the acquaintance of Dr. Edwin Land of the newly formed Polaroid Corporation. Ansel became a consultant for this

PLATE 29 left
Interior at Ruin Cliff Palace, Mesa Verde National Park
Colorado

PLATE 30 opposite
Cliff Palace, Mesa Verde National Park
Colorado, 1942

company and also continued to publish books well into the early fifties, producing three in 1954, all on photographic subjects.

Yosemite was always close to Ansel's heart, and using his skill as a lecturer, something he had been involved with for many years, he set up the Ansel Adams Yosemite Workshop as an aid to providing detailed short-term courses on photography as a creative medium. For many years this provided valuable help and encouragement as well as being a source of inspiration to new generations of photographers. He was also becoming increasingly aware of the poor quality of gift-shop produce, much bearing little or no relationship to a particular region and some not even made in America. Ansel decided to take steps to rectify the situation, producing a series of prints of superior quality, signed and inexpensively priced. These were sold in Best's gallery and became immensely popular with the public, continuing to sell in their thousands over the years.

During the 1950s, Ansel's creative output became somewhat diminished. He was still extremely busy but he was concentrating more on the commercial side of his career as well as teaching and writing. In the early 1960s, Ansel and Virginia moved to Carmel Highlands, to a new house designed to suit Ansel's professional requirements and which included a darkroom, office, workroom and gallery.

The house had awe-inspiring views over the Pacific Ocean. The living room, complete with a magnificent and well-stocked drinks cabinet was an often-frequented focal point, and Ansel continued to enjoy entertaining. Most evenings, the room was thronged with visitors, ranging from budding photographers to musicians and environmentalists – all eager to listen to Ansel's views.

The well-equipped darkroom was used for a good deal of the time as Ansel continued to make prints and experimented with new photographic materials. He also studied ways of improving the life of prints in storage.

Ansel grew in stature to such an extent that even presidents sought his advice. He continued to produce his portfolios while continuing to write and stage exhibitions receiving many awards for his work in photography and his service to the environment. He was now an extremely busy man; his new-found celebrity, along with continuing demands for his work meant that he had little time to go out into the field to capture new images. However, he remained an important exponent of modern creative photography, doing much to encourage new talent.

In 1967, a meeting took place at the house in Carmel Highlands when Beaumont and Nancy Newhall, Brett Weston, Cole Weston and others with a keen interest in photography were present. Their aim was to establish a

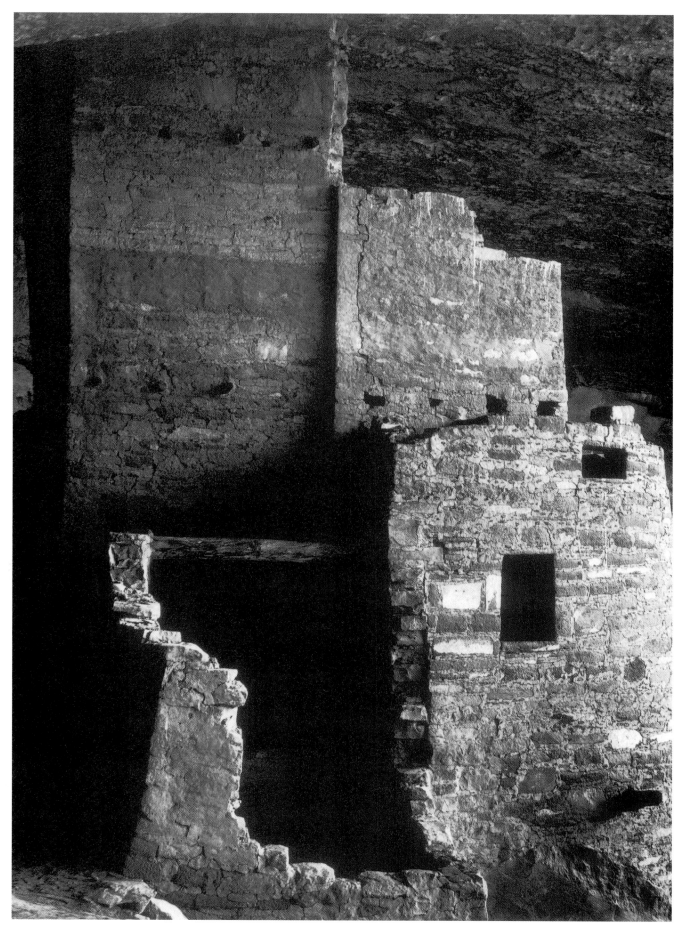

PLATE 31
Long's Peak, Rocky Mountain National Park
Colorado

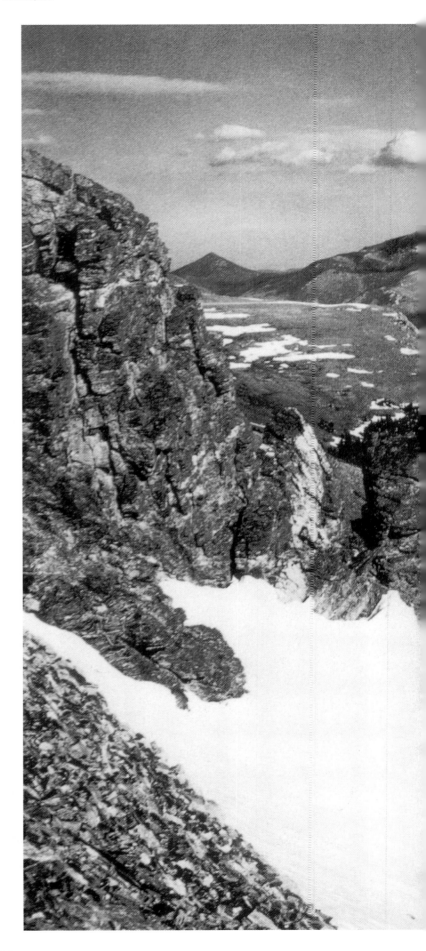

group that would promote the creative genre of photography as a fine art. It became known as 'The Friends of Photography' and Ansel Adams was its first president. This organization grew in importance, eventually becoming the largest creative group of its kind to exist worldwide.

Into the 1970s, Ansel's enormous popularity continued as demand for his work increased. He spent more and more time in the darkroom, resurrecting prints from past projects, but producing very little new work. Something needed to be done and he ceased taking orders for prints; but there was an enormous backlog of some 3,000 still to be made which took him over three years to complete. However, there remained an ever-increasing desire for more prints. In 1976, Ansel decided that he would play an important role in the formation of the Center for Creative Photography at the University of Arizona and it was here that his archive was established, resulting in an Honorary Doctorate of Fine Art degree.

In 1978 Ansel, who had a history of heart disease, underwent a successful triple bypass and an aortic valve replacement operation. This greatly improved his failing health, allowing him to enjoy a new lease of life with increased vigour to pursue his work. By 1980, Ansel had reached the very zenith of his career and was given the ultimate accolade – the Presidential Medal of Freedom. This was presented to him by Jimmy Carter who in his speech stated:

At one with the power of the American landscape, and renowned for the patient skill and timeless beauty of his work, photographer Ansel Adams has been visionary in his efforts to preserve his country's wild and scenic areas, both on film and on

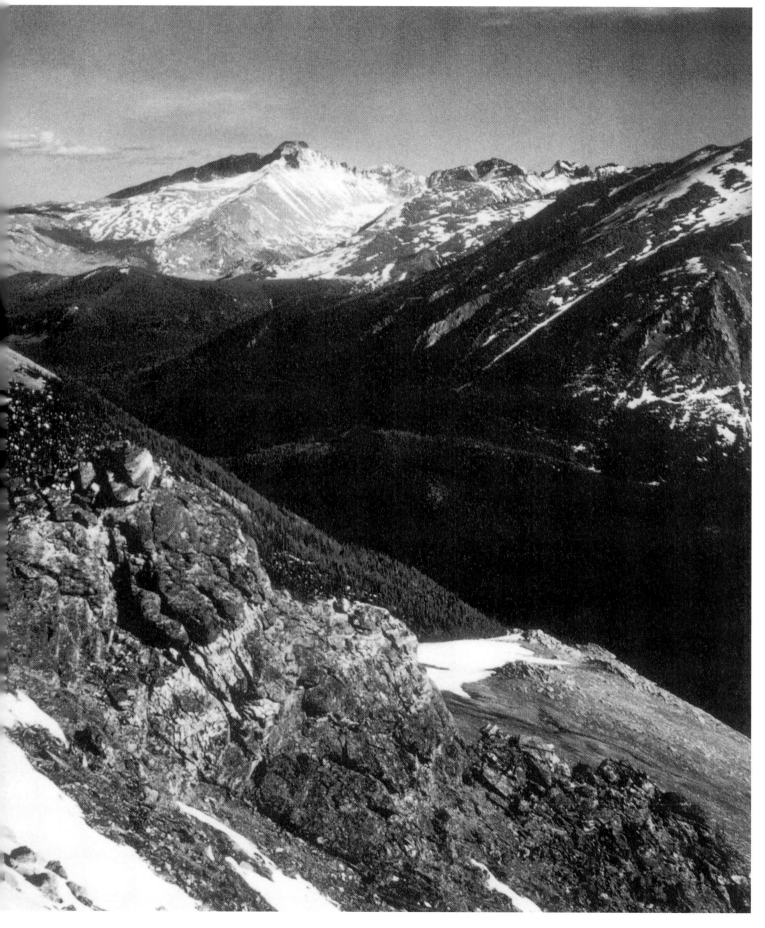

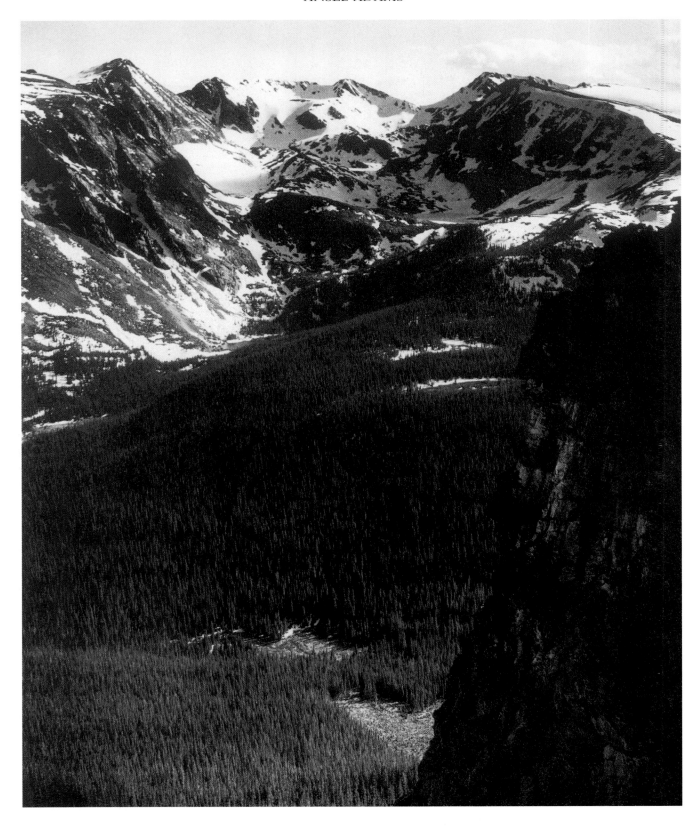

PLATE 32
In Rocky Mountain National Park
Colorado

PLATE 33 opposite above
Long's Peak from North, Rocky Mountain National Park Colorado

PLATE 34 opposite below
Moraine, Rocky Mountain National Park
Colorado

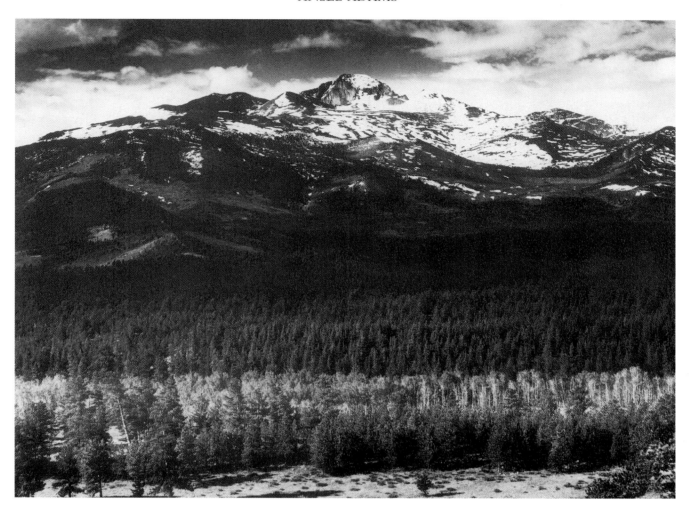

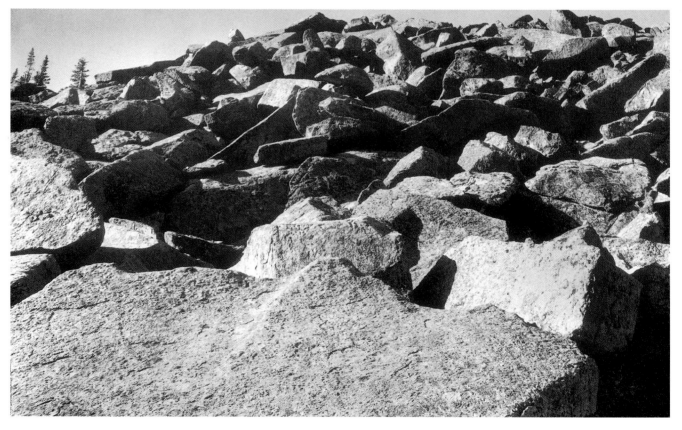

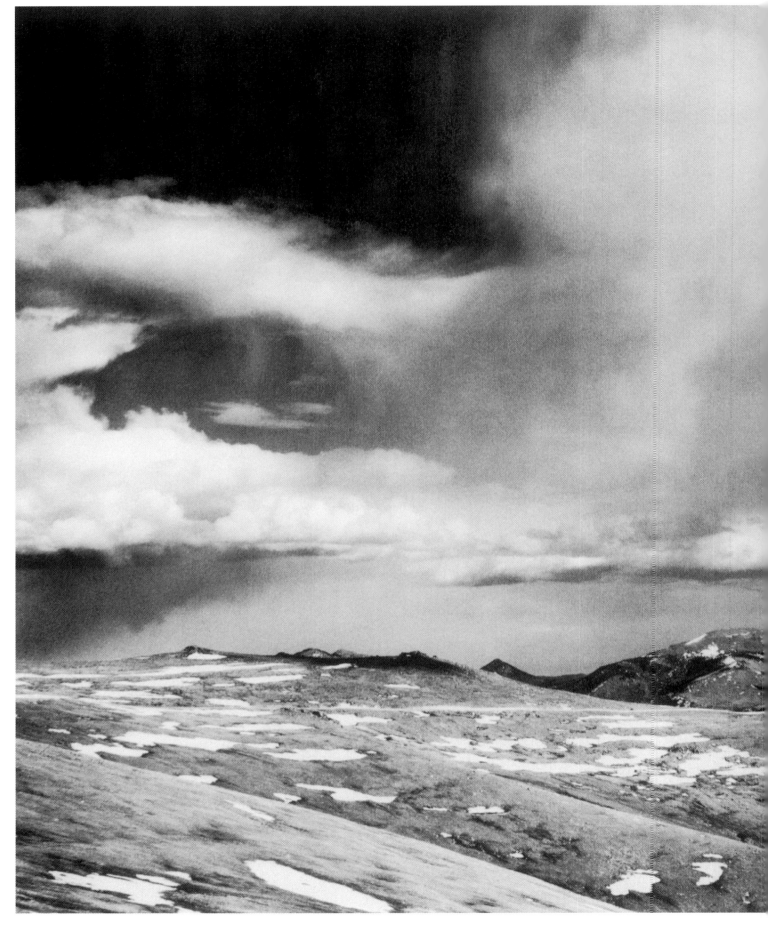

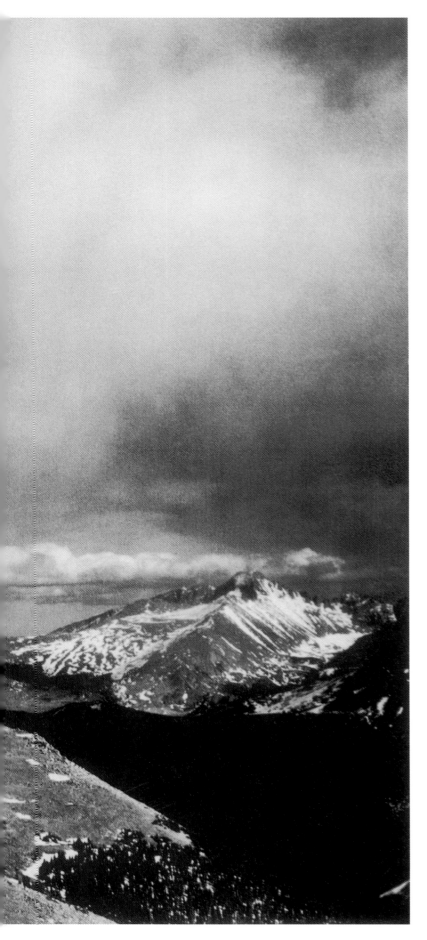

earth. Drawn to the beauty of nature's monuments, he is regarded by environmentalists as a monument himself, and by photographers as a national institution. It is through his foresight and fortitude that so much of America has been saved for future Americans.

This was the moment when the nation truly took Ansel Adams to its heart, coming to regard him as a national hero. Ansel was never egotistical and self-centred, but used his fame to foster his ceaseless campaign of protecting the environment. He used his celebrity wisely, capturing news headlines and writing many thousands of letters to newspapers and people in authority who would be likely to be sympathetic to his cause.

When James Watt was created Secretary of Interior during the Reagan administration, Ansel developed a strong antipathy towards the man, fearful that he would prove inimical to environmental issues and would begin to undo all the beneficial legislation which had been achieved between lobbiests and government. When he challenged Watt's environmental policies, the President sided with Watt, confirming that his Secretary was in fact merely carrying out his own wishes.

Though now in his 80s, Ansel never ceased to work. In the early 1980s he introduced his Museum Set project, which were groups of prints destined for museums worldwide and which aimed at improving their collections. He also wrote his autobiography and even purchased a

PLATE 35
In Rocky Mountain National Park
Colorado

PLATE 36
In Rocky Mountain National Park
Colorado

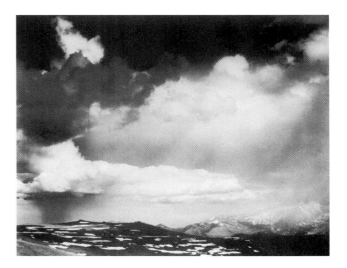

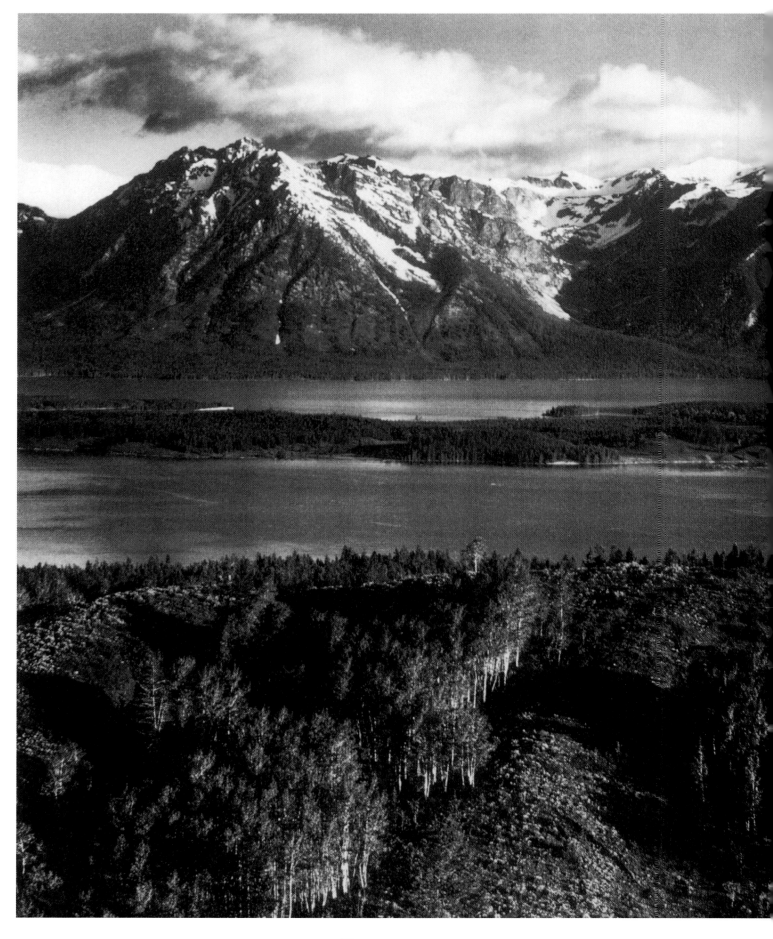

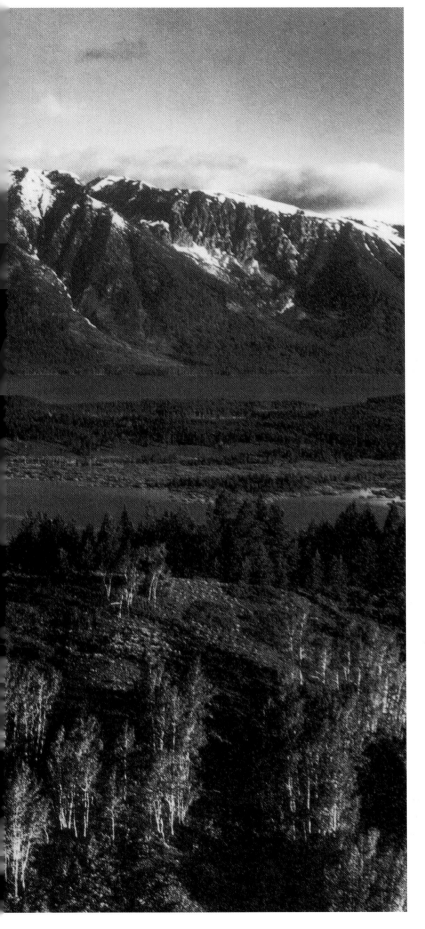

PLATE 37 left
Grand Teton
Grand Teton National Park, Wyoming

PLATE 38 above
Near Teton National Park
Wyoming

computer to help him in his task. In 1982 his heart problems began to reassert themselves and a pacemaker was fitted which resulted in a slight improvement to his health for the next two year. Sadly, he was to finally pass peacefully away on 22 April 1984: it was Easter Sunday.

Ansel left an wonderful legacy: his wealth of knowledge of the creative and technical aspects of photography continue to survive, not only in his many photographs spanning decades, but in his writing on the subject and the strength of his concern for the environment. Both Virginia and Ansel left endowments to further the Adams cause, making donations to the Museum of Modern Art for the creation of a permanent fellowship and bequeathing their Carmel house to The Friends of Photography. Although Ansel's death left a vast number of people mourning his loss, his life had not been in vain; he has achieved an enormous amount, later to be rewarded in 1984 with the Wilderness Bill, when it was passed by Congress and the Ansel Adams' Wilderness Area was created. Situated between the Yosemite National Park and the John Muir Wilderness Area, it spanned over 100,000 acres (40,470 hectares). A mountain was also named after him, one he had climbed in 1921, near the Lyell Fork of the Merced River, which was called Mount Ansel Adams, the ultimate accolade to a man who had dedicated his life to protecting and recording for posterity the transcendent beauty of America.

PLATE 39

The Tetons – Snake River

Grand Teton National Park, Wyoming

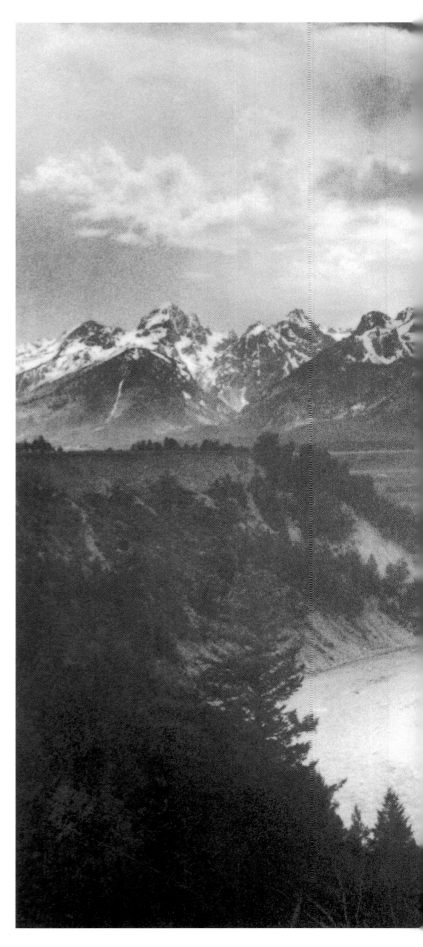

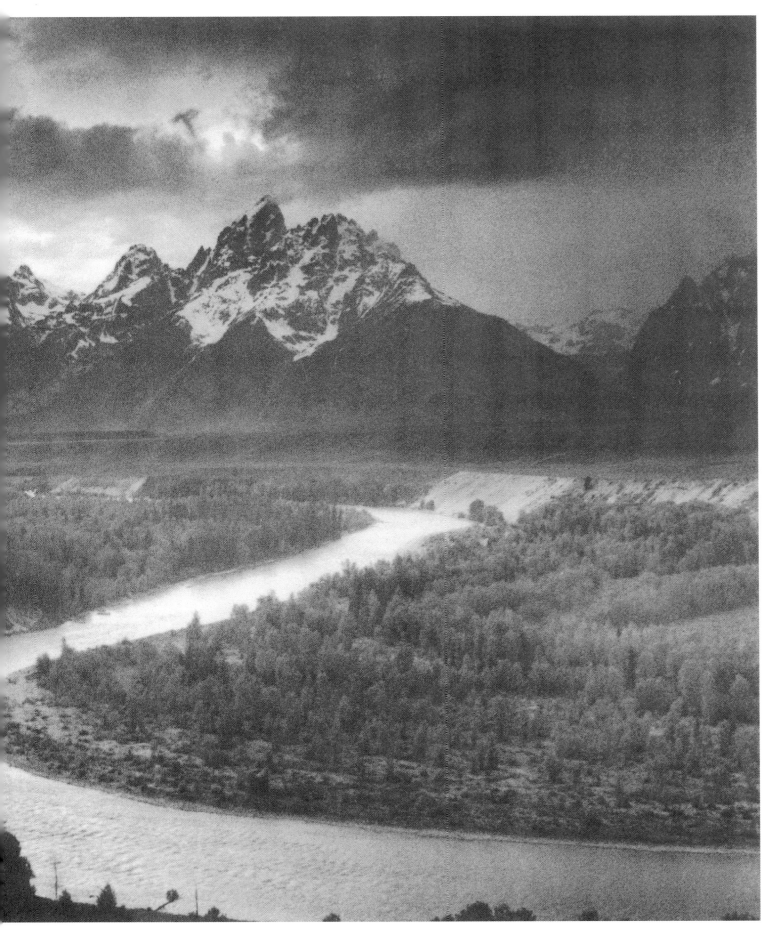

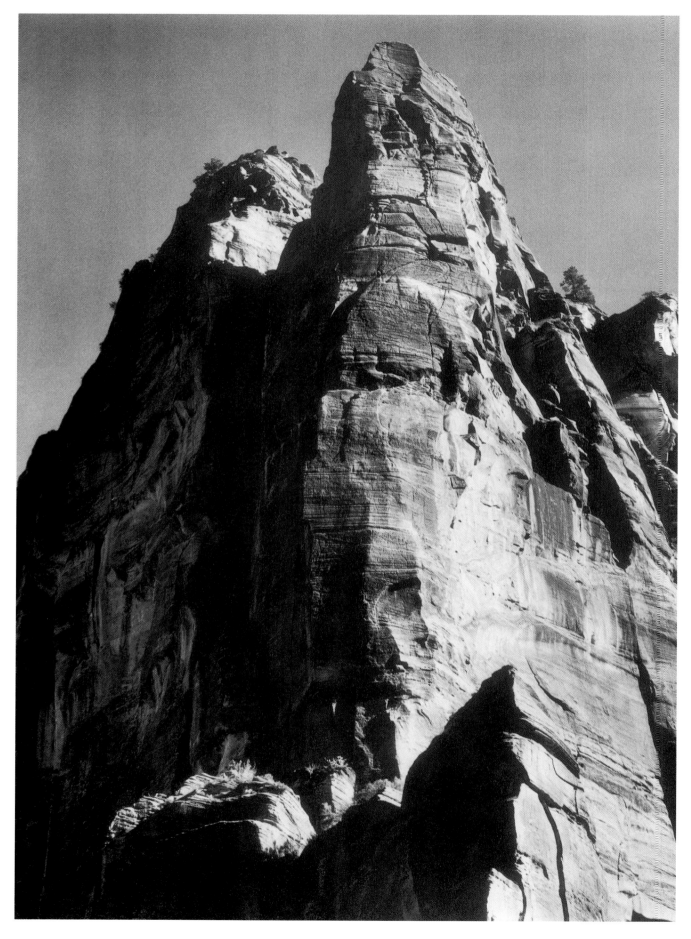

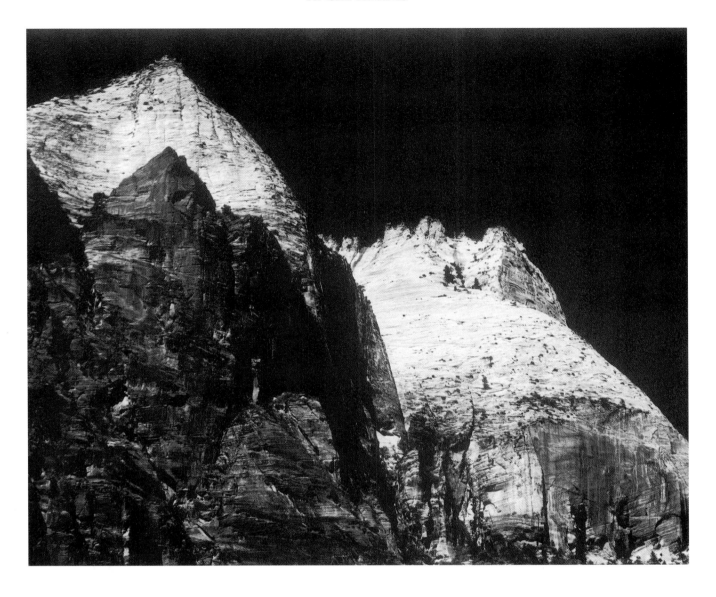

PLATE 40 opposite
In Zion National Park
Utah, 1941

PLATE 41 above
Zion National Park
Utah

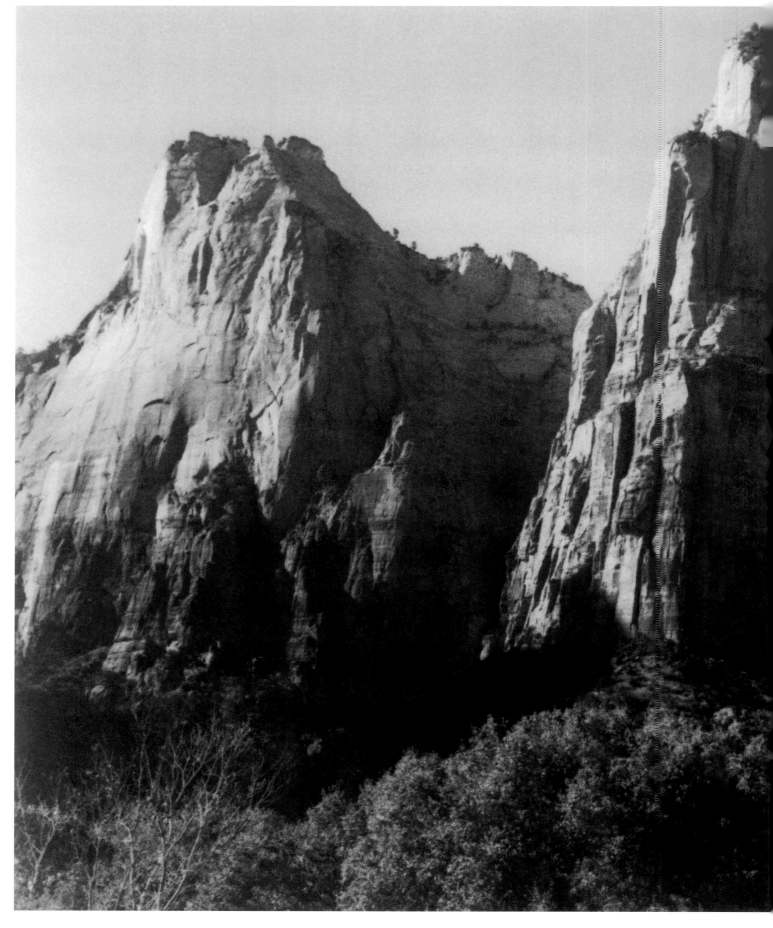

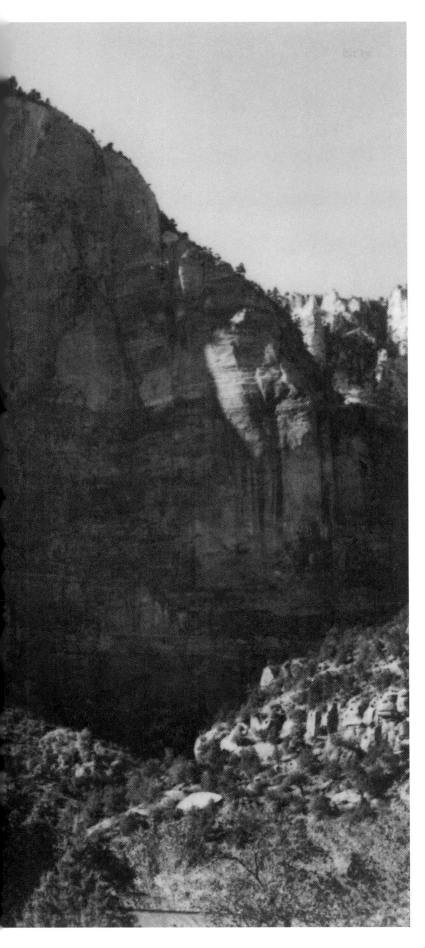

PLATE 42
**Court of the Patriarchs,
Zion National Park**
Utah

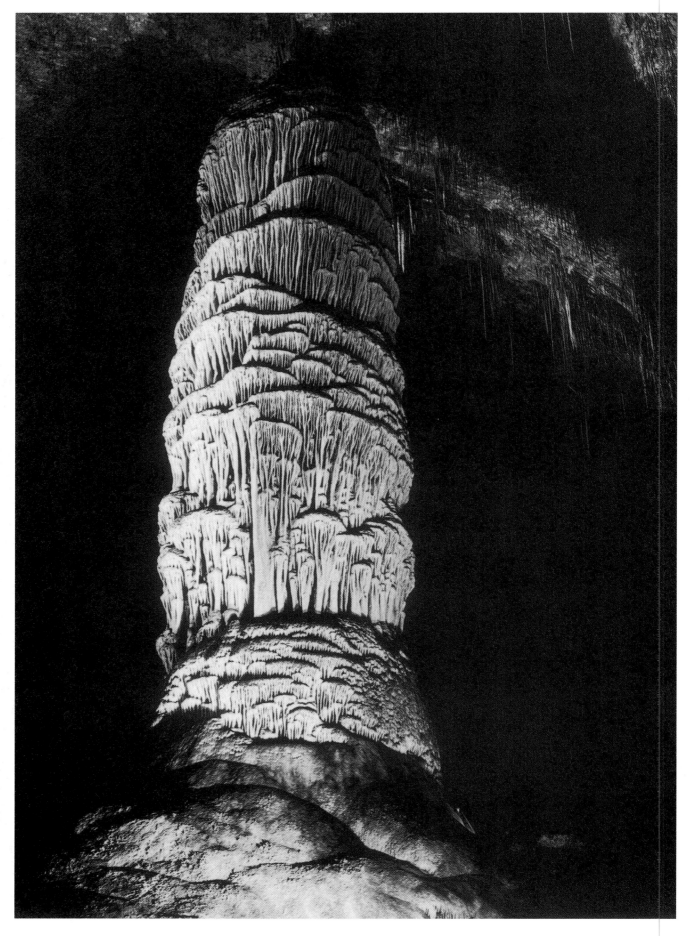

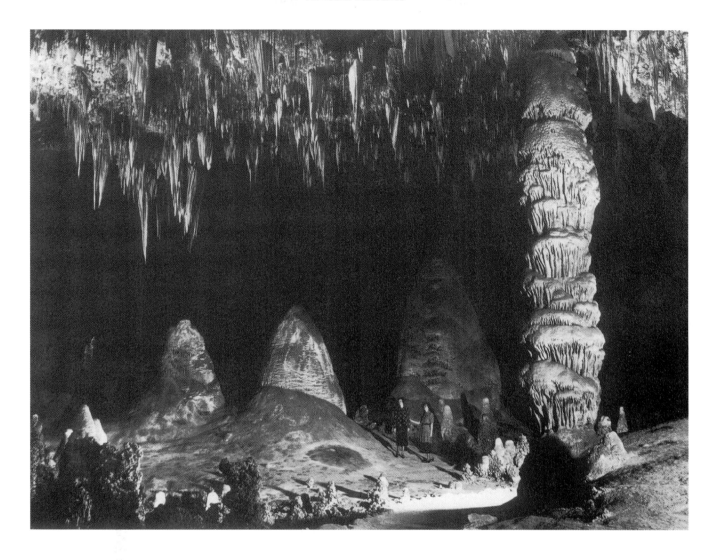

PLATE 43 opposite

Large formations or dome in the Hall of Giants, Big Room

Carlsbad Caverns National Park, New Mexico

PLATE 44

The Rock of Ages in the Big Room

Carlsbad Caverns National Park, New Mexico

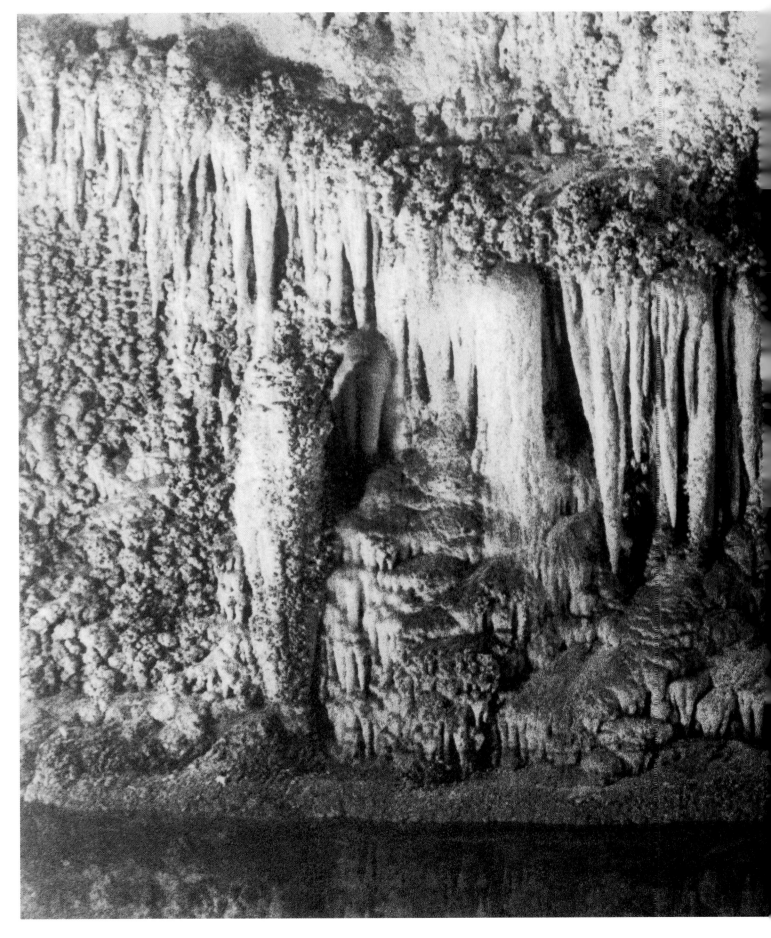

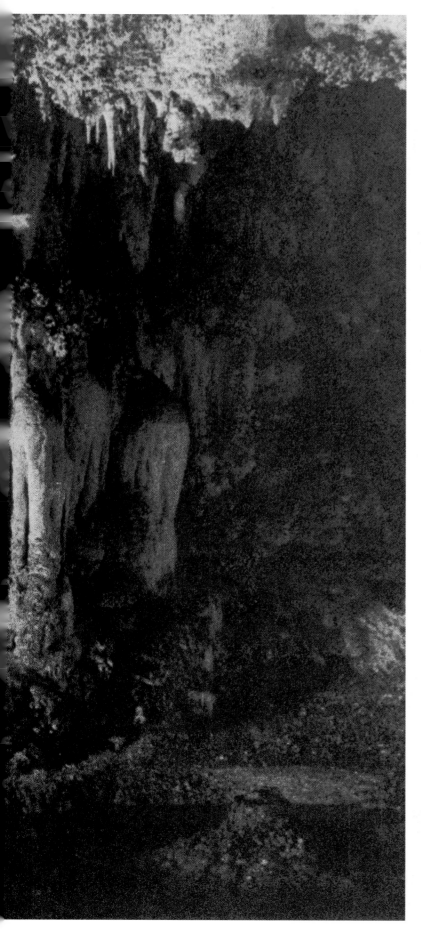

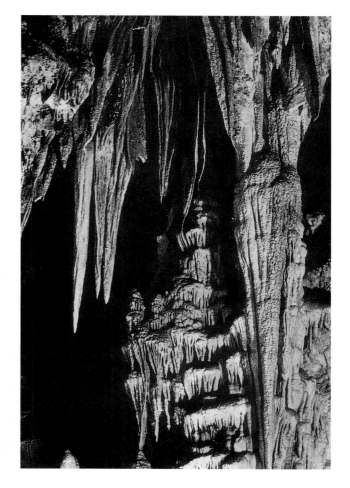

PLATE 45 left

Formations and pool, large drapery formation known as the 'Guillotine,' in the King's Palace

Carlsbad Caverns National Park, New Mexico

PLATE 46 above

Formations along the trail in the Big Room, beyond the Temple of the Sun

Carlsbad Caverns National Park, New Mexico

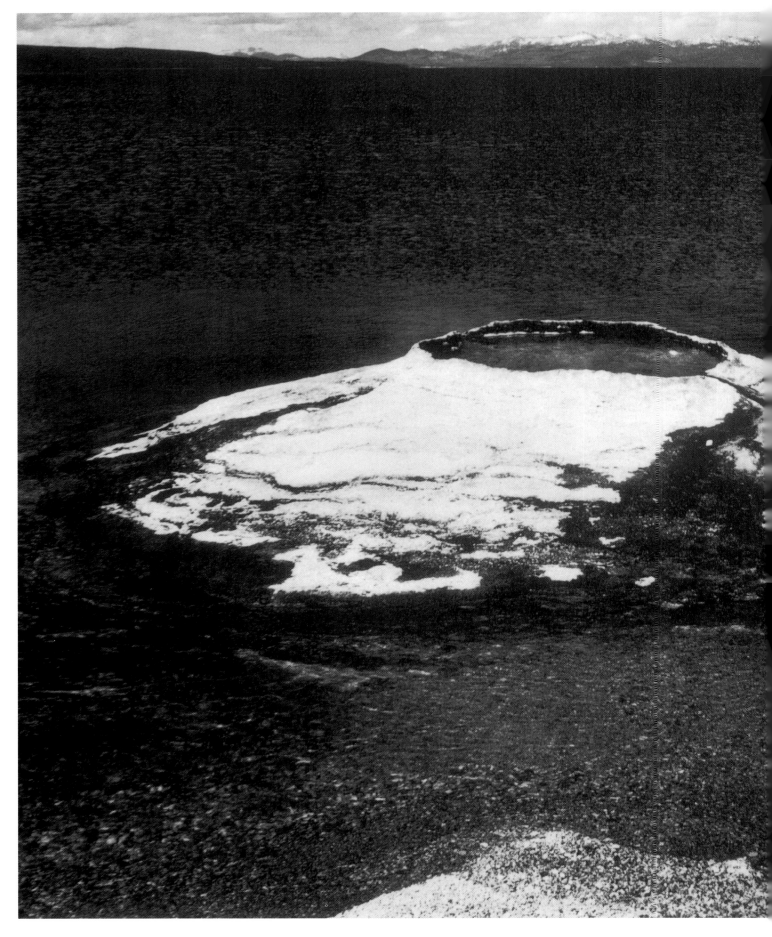

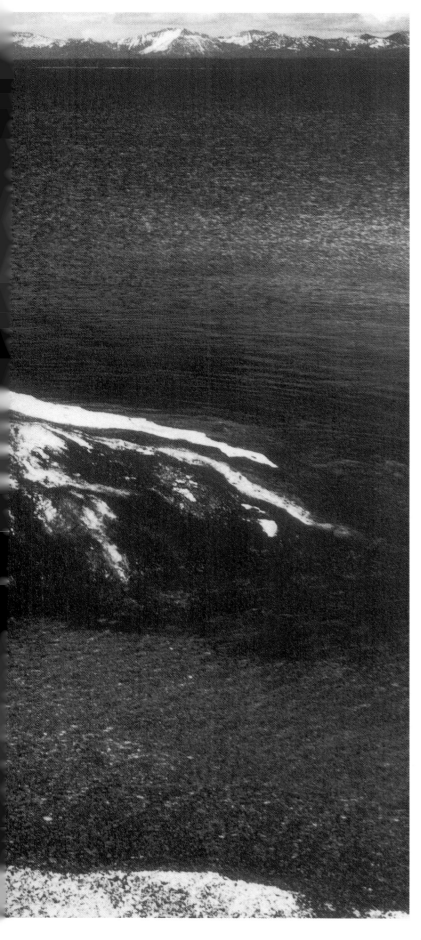

PLATE 47
**The Fishing Cone – Yellowstone Lake,
Yellowstone National Park**
Wyoming

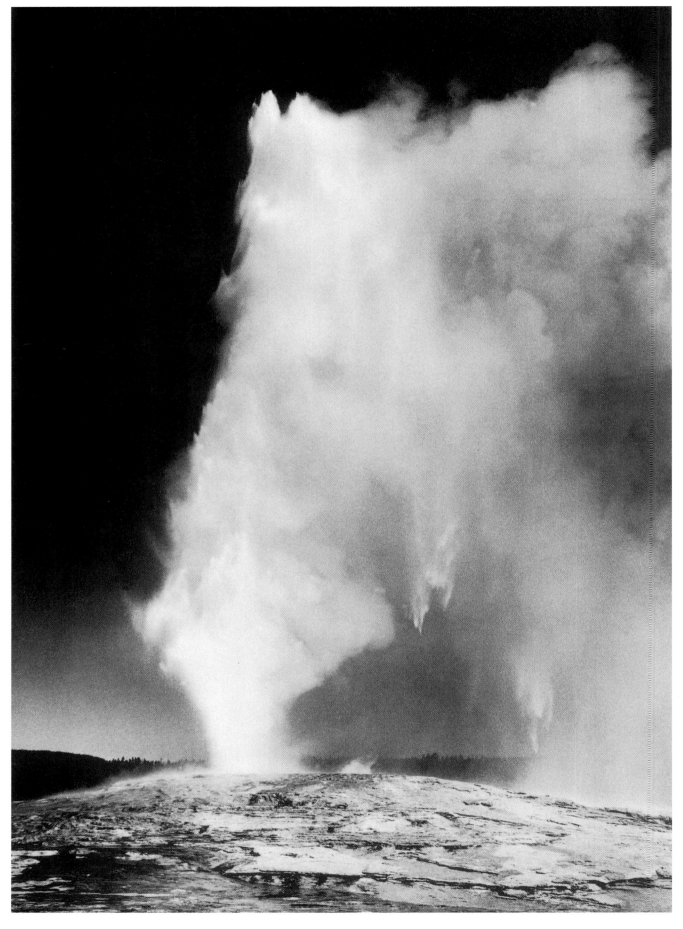

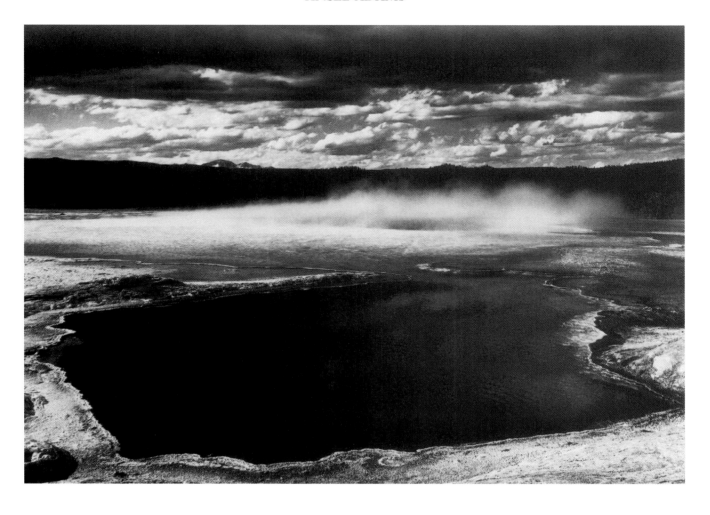

PLATE 48 left
Old Faithful, Yellowstone National Park
Wyoming

PLATE 49 above
Fountain Geyser Pool, Yellowstone National Park
Wyoming

PLATE 50
**Roaring Mountain, Yellowstone
National Park**
Wyoming

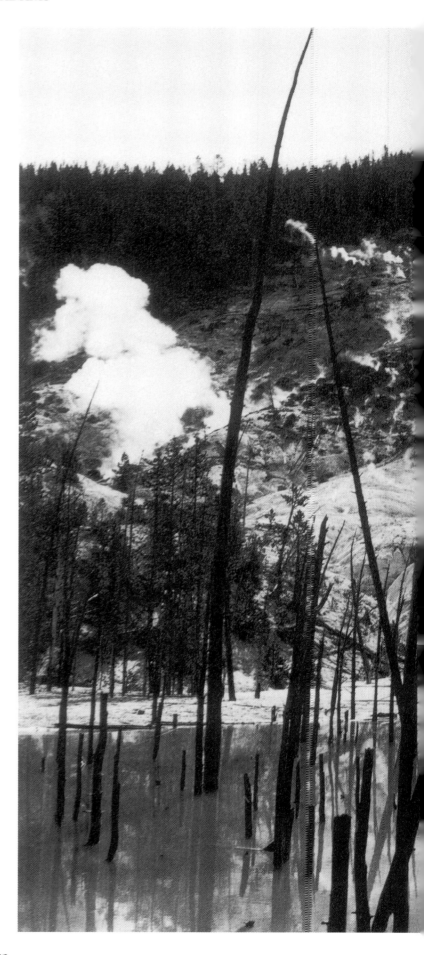

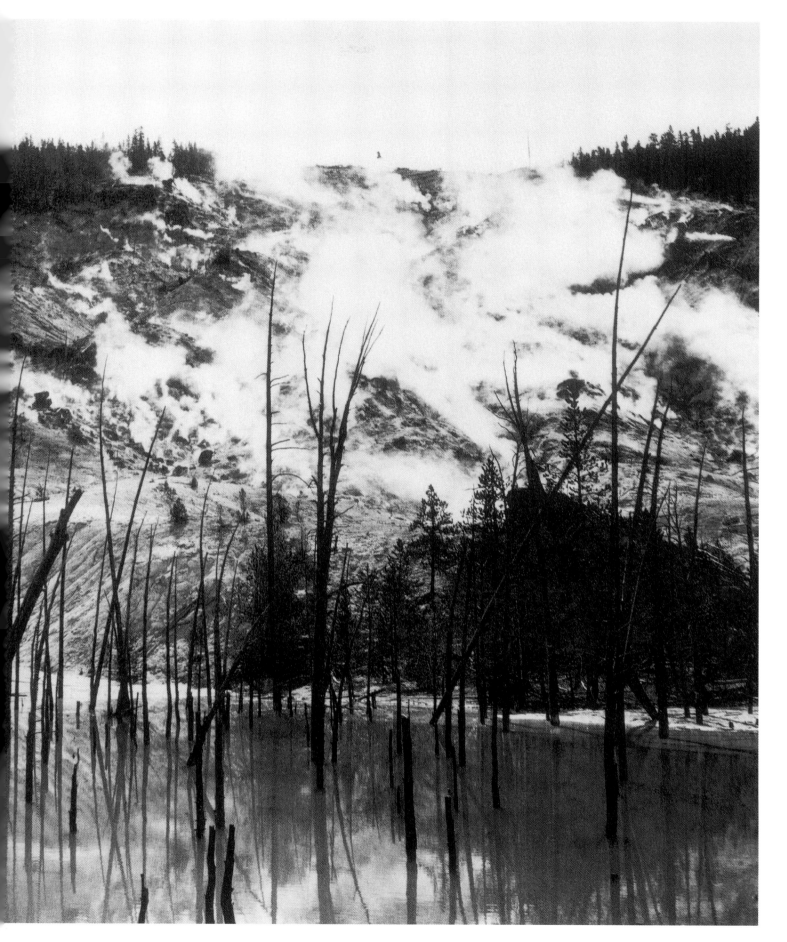

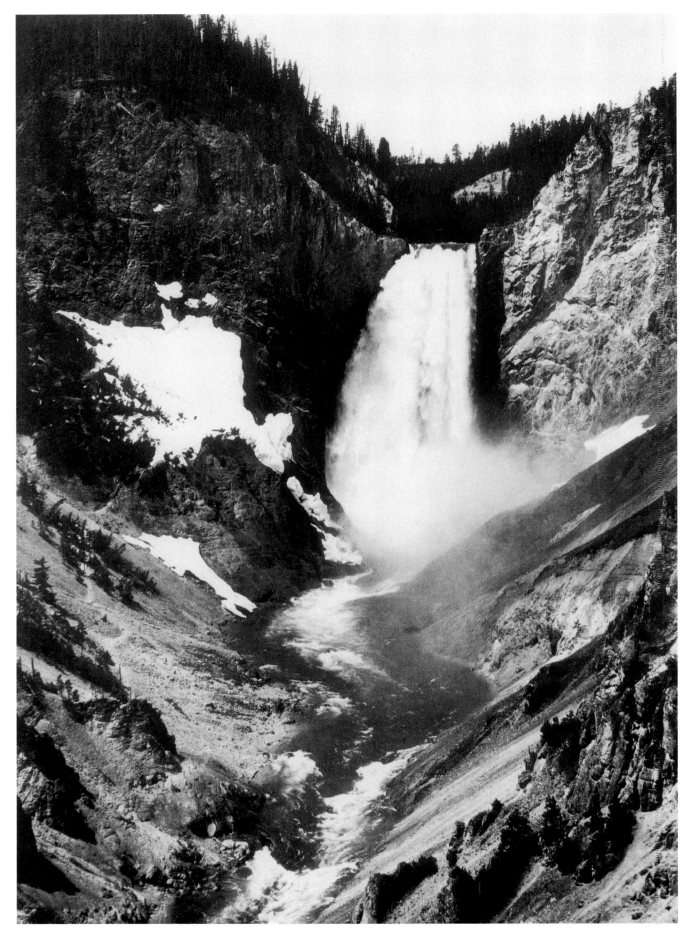

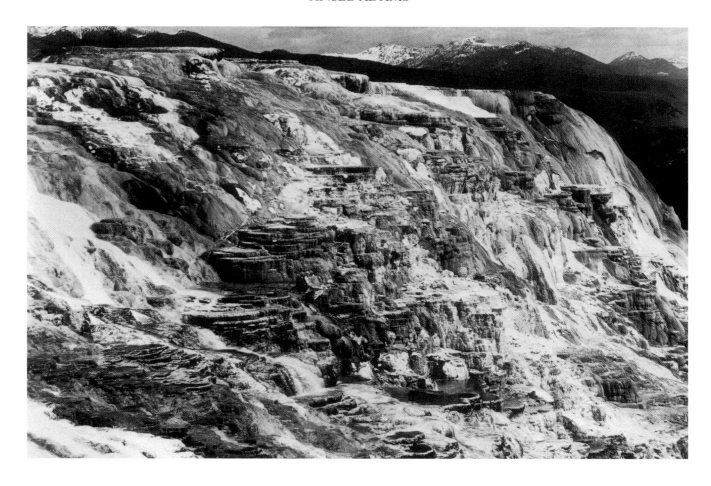

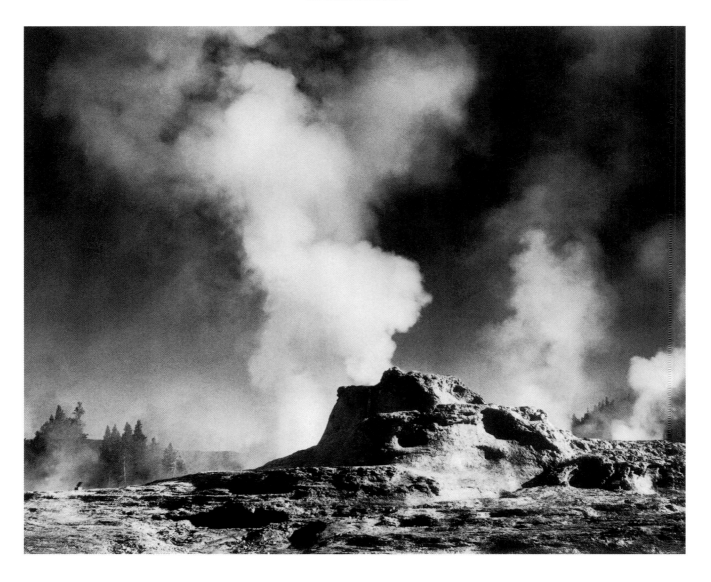

PLATE 53
Castle Geyser Cove,
Yellowstone National Park
Wyoming